To Beka
with love,
admiration,
friendship.
♡ Care—

Power

Power Stories

Everyday women
creating extraordinary lives

Cara Gubbins, PhD ~ Laurie Santulli
and Fran Taylor Powers

Stories Contributed by
Powerstories Theater Performers

JADA

POWER STORIES

Published in 2004 by JADA Press
An Imprint of Marglen Publications
Jacksonville, Florida
www.JadaPress.com

ISBN: 1-9329-9300-2
Library of Congress Control Number
LCCN: 2004109440

Printed in the United States of America

Life can only be understood backward,
but it must be lived forward.
Niels Bohr

We dedicate this book to the people in our lives who
have opened our minds and hearts and we invite our
readers to have the courage to seek and speak their
own stories.

Acknowledgements

It takes passion, action and a lot of support to make dreams come true.

This book has been in the making since the day we were born, but is only coming to fruition now at the exact time it was meant to. It is the natural next step in the Powerstories vision to stage true stories worldwide that began with a small theatre project in Tampa, Florida in 2000. Therefore it is most appropriate to show our appreciation for those that have supported all of Powerstories, including the book project.

First, our gratitude to the many women who have courageously shared their stories at auditions, workshops, or a theatre performance. It is never easy seeking a significant story to share then standing in your space and telling it. A very special thank you for the women who have performed in theatre events and were contributing authors for the book. Powerstories is simply not possible without all of you...the tellers!

Next, thank you to our audiences. Without you sitting in the darkened theatre or the classroom, the stories could not be heard and they would not live on. The audience plays a vital role in any perform-

ance event; without you there is no story to be heard. We recognize that your time and money is precious and we are grateful you choose to spend some of it furthering our mission.

Then, we thank the many behind the scene supporters for the theatre and book project. Some of those supporters include: The Board of Directors, Jan Bates, Dr. Barbara Morrison Rodriguez and Carmen Spoto; private Foundation contributors, The Conn Memorial Foundation, The Community Foundation of Greater Sun City Center "Helen Hill Fund and the George Lutz Fund," and many individual supporters of time, talent or treasure. Some of those individuals include Debbie Baker, Toni Beddingfield, Kitty Bryan, Kim Callan, Karen Conley, Kym Dolcimalscolo, Audrey Ellison, Judy Gay, Kathy Gaye, Carole Gill, Joanie Halfaker, Kim Hanna, Lizz Harmon, Diane Jamai, Sally Lindberg, Irene Levine, Jewell McKeon, Chef Kim Miller, Lydia Muhr, Gwen Parsons, Lila Purifoy, Julie Ravelo, Sheri Whittington, Jill Somers, Sally Speer, Ofelia Via, Melinda West and Judy Wade.

Very special thanks go to Glenda Ivey of JADA Press and T.C. McMullen for their book publishing and book cover guidance, Billie Cox-Glimpse who regularly donates workshop space at the Gold Dragon Gallery, Marty Miller who donated space at Baywinds Learning Center for the Writing Workshop, Dan Rocha, our resident photographer

and general contractor, Susan Mike, who provided seminar development expertise, Janet Scaglione, Brad Tisdel and Jim Beckwith for their gift of song, Antoinette Wheat for her Certified Public Accounting assistance, Maggie Osborn for Powerstories product development, Stephanie Powers for two years of stage management, and Rosalie Hennessey for on-going encouragement. Thanks to Chris Eckland and Peter Gubbins for providing editorial support and expertise during production of this book.

Most importantly, our gratitude goes to our immediate family and friends who have spent countless hours listening to our ideas and sharing our lives. A heartfelt thanks goes especially to our husbands. To Chris Eckland for the generosity of his love and spirit and his uncanny ability to make Cara laugh just when she needs it most and expects it least. A better partner for life's adventures is hard to imagine. To Rick Plummer for his steadfast faith in Laurie as she navigated through the uncertain waters of her spiritual and emotional awakening. To Dick Powers for his love and continual support for a wife who firmly believes one person can change the world. His patience has been tested over and over, and he still chooses to love and support.

Table of Contents

Clarity Cometh

Seek and Speak Your Story Workshops

Foreword

My girlfriends and I were long overdue for a "Girls' Night Out," so when this energetic, passionate woman stood up at our NAWBO (National Association of Women Business Owners) meeting and starting talking about her company and its performance that weekend, I was intrigued. She mentioned that she had created a venue for women, with no prior theatrical experience, to tell their stories on stage about the challenges and triumphs of their lives. The show was designed to inspire and encourage women in the audience going through their own ups and downs, letting them know that they weren't alone. Being a psychiatrist and seeing many women in my practice, I was elated at the chance to experience a new setting for women to heal together.

I called my girlfriends, a diverse group made up of psychologists, mothers, homemakers, entrepreneurs

and receptionists, and, oh yes, I told several of my clients, and encouraged them all to attend. Fortunately, several of these women did venture out, all looking for different insights or just to be entertained, and yet all sharing that intimate bond of womanhood and the journey that brings us together. From the moment the curtain opened, we were pulled in. We belly laughed out loud, teared up, sighed relief, and cheered. Every woman around me in that theatre was involved, affected, moved, no matter her age, pre-teen, thirty-something, or mature adult.

When the curtain closed, the crowd cheered and jumped to its feet. We wanted more! The feeling of connectedness, the exhilaration of seeing these women overcome their obstacles, the inspiration that we, too, could triumph over our challenges and be enriched by the process were glorious! Outside the theatre, it was like one big Girls' Night Out. Everyone was talking and sharing, laughing and expressing. Everyone that I had invited came up to me and thanked me. Most touching was a mother and teenage daughter that I saw in my practice and the group of mother/daughter friends that they brought with them. They were all empowered by the show, each getting something different and emphasizing the story of a different woman on stage. Themes that we had touched on during our sessions came to life for them during that performance. We were all so grateful for the experience. Of course,

thinking like a therapist, I was excited and impassioned by the idea of how numerous women and men could benefit from this therapeutic theatrical process without the stigma of being a "patient" in therapy.

My brain was going a thousand miles a minute. I couldn't wait to contact Fran Taylor Powers, the creator of this masterpiece, and share my thoughts and ideas on how to reach even more women. I emailed her that very night and told her that this was by far the best production I had ever seen anywhere, even on Broadway. Why? Because individuals were so moved in a positive, intimate and profound way by women just like them. It was real! She wove the stories of these women together with impassioned music, simple yet effective colorful props and an underlying theme that truly did "Let the Stories Move You." These were ordinary women who found the extraordinary within them and made their lives work.

I also told Fran that I envisioned a huge seminar, filled with women of diverse backgrounds, age groups and life experiences coming together to watch the show, connect with a particular performer or theme in the show and to then participate in a workshop that included that performer and an expert in that field to facilitate understanding, sharing, and developing their own Powerstory. Fran loved the idea and the *It's Possible!* Seminar was born. I found out soon after the birth of this seminar idea, that I

was pregnant with my first child. The seminar was the perfect focus for me during this most beautiful time of my life. I was able to nurture myself and my developing baby from within as we assisted other women to do the same. It was an amazing, joyous process. The result was over 200 diverse women coming together for a full day of theatre, real life stories, reflection, enrichment and inspiration. What a rush!

Storytelling has many blessings. As Jack Maguire explains in his book *The Power of Storytelling,* "[storytelling] invests our lives with more meaning, connects us more vitally with others, develops our creativity, strengthens our humor, increases our courage and confidence and renders our lives more memorable." Most importantly, an effective story should be skillfully drafted with an audience in mind and "aim toward acceptance, resolution and self-transcendence." This enhances the therapeutic effect for the listener/reader, who is looking for insights, camaraderie, hope and encouragement. The twenty stories in this book have been designed with the skill Mr. Maguire describes and that is why they are so effective. The many women who have experienced these stories have enjoyed these bene-fits. Reading them yourself will allow your confi-dence, courage, life enrichment, connections and humor to emerge as you willingly open up and get real with this process.

Every human being, female and male alike, has the extraordinary within, waiting to be embraced and set free. You are one of those human beings. Whether you are a business executive, physician, therapist, mother/homemaker, teenager, philanthropist, or business owner, there is a story here that will rouse you. Enjoy this book during those precious moments of solitude that are all your own and Let the Stories Move You! You'll be amazed at the insights you gain and the transformation you will experience within yourself.

Susan List Mike, M.D.
Joyful Genius, Inc.
Jupiter, Florida
March 2004

Let the Stories Move You

On the night of January 11, 2000 a group of 42 women gathered at a 500 square foot studio on the third floor of an old cigar factory in Tampa, Florida to hear about Powerstories Theatre. The new theatre, founded by Fran Taylor Powers, would be about women by women and the paramount purpose would be to awaken passion and inspire action in others. The vehicle to accomplish this would be telling powerful personal stories.

The women entered the space, which was filled with candles, inspirational books and pictures of influential women, and they were all eager to learn more. They were from diverse backgrounds and occupations and most had never performed on stage before. A few had come from over a hundred miles away because they, too, had seen the press releases that asked, "Do you have a story to tell?"

Fran sat on a stool on the first Powerstories stage and shared the story of the birth of her theatre and her vision for it. She was looking for seven women who had inspirational stories that they were ready to share with others. They would be volunteering long hours together to rehearse an original show that would be created around their stories. Fran was honest about not knowing where it would go, but promised they would get an opportunity to perform at least six times. The question most frequently asked was "what type of story are you looking for?" and the answer was always the same: "If you could share a piece of your life with hundreds of other women so they could learn from it, what *story* would you tell?"

Auditions were held March 28th and 29th and by April 5, 2000, seven women were selected to perform in the first production. Throughout the spring and summer, the women worked and re-worked their stories and Fran wrote the script to connect their stories. "Let the Stories Move You" was born. By September 2000, the script was being memorized, a set was built, a theatre was rented and seven amazing women were well on their way to an incredibly empowering experience.

November 16, 2000 was opening night. The excitement back stage was electrifying. Fran and the seven women stood in a circle just before the show and prayed, "Please show us the fullness of our power

and guide us on how to use it, so that we may share it with others." One performer was so nervous she felt sick to her stomach. To quell nerves, the group would remind each other, "We are doing this to give a gift to others." When the theater went dark after the last story, the audience rose to their feet and applauded and applauded.

Today, "Let the Stories Move You" is in its fourth year of performances. Over the years, some cast members have moved on to other projects and new women and their phenomenal stories have been added so that the show always includes seven stories. In the following section, the stories of most of the women in this production are presented. Read on and let the stories move you.

The Birth of Powerstories

Fran Taylor Powers

One day in my early 40s, I rushed into the Doctor's office irritated that she kept me waiting. She was a very expensive specialist I was seeing for the first time and I expected my name to be called at the appointed time, not forty-five minutes later. As I was ushered into her office, and before I even said "hello" or sat down, I blurted, "Doctor, I am either going to leave town, quit my job, divorce my husband or commit hari kari. You have got to fix me!" It was more like a demand, and I meant every word.

Later in the early evening as I was driving home from my job as Executive Director of a large shelter for pregnant girls, I reviewed my day's accomplishments. Packing in a wide range of tasks every day was typical for me. Negotiating with funders on a

new housing project, hiring a counselor, and speaking at "the" fashion show of the season on the needs of adolescent pregnant women were all in a day's work. A local paper referred to me once as "the hammer with a velvet touch." I secretly felt it was the perfect description.

One mile into my ride home I wondered what details I forgot and needed to get done by eight o'clock the next morning. I was forgetting a lot of little things lately. My mind fast forwarded to tomorrow's schedule and backtracked again on the day's activities. Then, the words I had unthinkingly blurted out to the doctor suddenly came back to me with crystal clarity. As if someone from above threw a bucket of icy water on me, I jerked backwards and pulled over to the side of the road. It was like a friend saying, "Okay, maybe this will stop you!" …And it did! I sat holding the steering wheel in my blue Camry on the side of a beautiful residential street shaking, staring into space and gasping for air. "What Am I Doing Here?" I asked myself and I was not referring to the side of the road.

I was unusually quiet fixing dinner, not wanting to reveal my sadness and annoyance with myself to my husband. While I opened a jar of Prego for a quick dinner of spaghetti and "homemade" sauce, I wondered how I got so far off track with my dreams. I set two placemats down on the kitchen counter and contemplated how I could get back on course. By the time I lay my head down to sleep that night I had

decided to make some changes in my life. First thing tomorrow I would make a list.

The next morning I gave myself an extra fifteen minutes to sit outside in the backyard, sip another cup of hot coffee, and make a long list of how to make my life better. I did not notice the azaleas in bloom or see my puppies search for lizards. What I did notice was my long list of dos and don'ts. One of my things to do was to find more quiet time for myself. But, even as I circled it over and over with resolve, my mind fiercely fought getting quiet.

In an effort to get quiet, I would sit outside every morning for weeks and walk around the yard. My mind did not want to cooperate. I knew there was so much to do at work and I felt guilty taking this quiet time. Being raised Catholic lends itself to the comfortable feeling of guilt. I was cheating my employer not working 10 hours a day, wasn't I? But, finally, finally my mind became more still. I began to see the flowers in bloom and noticed the pink and gold detail of the croton leaves. I saw how my puppies gathered at the corner of the yard each morning waiting for the squirrels to leap from tree to tree, and I began to remember scenes from my life.

I remembered being twelve years old. My big sister Liz and I used to love to act and sing. We shared a room together and I remembered our first record player, received as a shared Christmas gift. We placed it right between our two twin beds and were constantly playing Herman's Hermits, The Supremes, and The Beatles. One day we sat in the

bottom of the shower and made up a song about the Beatles. We knew they would sing our song on stage some day and we would be the back up singers. My childhood was filled with dreams of being on stage.

I remembered my apartment in inner city St. Louis when I was nineteen and how I took the bus every day for months to get to my job at Jewish Hospital. Mom and Dad were still raising my little sisters and brothers, so I needed to put myself through college. As I rode the bus all bundled up with winter wear, I knew it was worth it because I was fulfilling my dream of getting a degree in Theatre. One day when I had only one year of college left, I was so despondent over finances that I walked into my boss's office and said "Mr. Corbin, can I work full time? I just can't do it anymore, it's too hard." Not missing a beat, he quickly said, "You are going places, Fran, and you need the degree to get there. Go home and figure out how much you need and I will personally loan you the money." His vote of confidence surged through me and helped me see a way to do it without his loan. One year later, I was the first in many generations of my family to graduate from college.

One scene with my mother kept coming back to me in bits each morning. I was seven years old and we had just moved into a three story old white wood-framed house in dire need of repair in southern California. We were always moving because Dad was in the Navy and was transferred often. It was early in the day when I should have been at

school, so I had Mom all to myself which made me feel very special. Mom was ironing Dad's shirts and I was sitting at the dining room table in the chair closest to her. With my elbows propped together on the table, chin in hand and legs swinging, I listened to Mom tell stories. This one morning Mom told me a love story about a woman named Betty but in my backyard in Tampa thirty years later, I couldn't remember all of the details. Finally, after days of searching my memory, the scene became clear. I knew the ending, which was the exact detail I was desperate to remember.

"Betty was 28 years old, a waitress, and divorced mother of two children. I think it was just a typical day. Betty was behind the counter frying burgers or pouring coffee. It was at JoJo's Diner. Then, she noticed this sailor walking through the door. He was 25 years old, tall, lanky with slicked back black hair. Ohhh ... so very good looking. Their eyes met and locked for just a moment. Then he walked right up to the counter, sat down on a red vinyl stool that was split from wear. He opened the menu and ordered the workingman's lunch special of roast beef, mashed potatoes and peas. Little did she know, he was awestruck with her and was desperately trying to figure what he could say to make her notice him."

"That man had three cups of coffee and three pieces of chocolate pie and he was still too shy to ask her out. I guess he was just so full that he final-

ly opened his mouth and asked her an unbelievable question!

"Are you ready for this question Francis Clare? It's an important question to always know the answer to. Always!"

"Yes, Mom, I remember. He asked her, 'What is the one thing I can give you to make you the happiest woman in the world?'"

Mom nodded as if she taught me well and continued. "Betty knew the answer to that very important question. She knew what her dream was ever since she was a little girl growing up on a farm in Minnesota, but she never told anyone; never felt safe enough. But this day was magical so she wiped her hands off on her greasy apron, tucked a clump of hair into her hairnet, stood up straight, took a look right at him and said, 'Since you are asking,'" Mom began and I stood up and chimed in with her, "I have always wanted 12 children!"

"Betty wanted a happy dozen." She laughed and laughed remembering this part, which always made me happy. "Now, she felt certain he would fall off the stool, or choke or run out the door. But, he just sat there and stared at her. He did not leave. In fact, 10 years and 6 children together later at the age of 36…Betty gave birth to your sister Judy Ellen, and she prays to have four more children so that she can say, "My twelve dreams were literally born!"

That was it! I remembered the last sentence when Mom would say, "My dreams were literally born." And she did have four more children, my sis-

ters Cathy, Ruth, Margie and my brother Charlie. She got her happy dozen. I recalled how happy and content she was with her life. That was what I craved…to love my life with passion and use my gifts in a way that made me and my family joyfully happy. With my new enlightenment, I decided to do something that would radically change my life. I stood up, hurried inside, sat at my computer and wrote a resignation letter from my job that I had loved for five years. It was meaningful work and I loved my career and worked hard at it every day, but it was no longer fulfilling me. It was fulfilling others, but not ME. As I crafted the letter, I would pause in moments of panic, and then I would remember my mother living her life with purpose. Mom always knew what she wanted and she accomplished it by courageously acting on her desires. Today was my day to act and to seek my passion. As I read the final letter I knew big changes were ahead. I was on a quest to discover my life purpose.

The next year was a whirlwind of joy and fear as I began a consulting and speaking company. The challenges at times felt insurmountable but the delight I felt knowing I was moving in the right direction made it worthwhile. That year was one of the most exhilarating, spiritual years of my life, filled with self-discovery and fresh insights. One morning, again with nature in my own backyard, I knew I was still holding back so I decided to crank it up and make another life altering decision. I had coveted an adventure dream for 30 years — not real-

ly thinking I would ever do it. I wanted to ride a bike across the United States, which required me to step way outside my comfort zone.

On June 15, 1998, I found myself in Seattle, Washington on a football field, with 700 others who were ready to tackle their dreams of riding a bike across the United States. My husband of 13 years was with me that day, seated up in the stadium at 4:30 am with other family and friends. They could look down and see all the cyclists bustling around, waving to the crowds above, and hugging each other. I, however, was completely still, with a death grip on my handlebars, so frightened I couldn't breathe. I slowly looked to my right and saw hundreds of men. One had his butt straight up in the air, looking at me and grinning from ear to ear, ready to RACE. Then I looked to my left and saw another man with muscular arms and legs. He, too, was obviously ready to race me up Snoqualmie Pass on this cold Seattle morning. I recall thinking that this ride was raging with testosterone everywhere and was feeling more like a competitive race than a charity ride.

Then I remember looking straight ahead and seeing a large platform in the middle of all the riders. The President of the American Lung Association was standing there in a coat and tie, microphone in hand and congratulating all of us for raising thousands of dollars to fight the dangerous effects of smoking and giving us words of encouragement. I don't remember much of his speech

though, because all I could hear was that same question in my head, "What Am I Doing Here?" It was so loud I thought the speaker would hear my inner voice, stop speaking, point directly at me and say, "You, Francis Clare, stop doubting yourself!"

Finally, he said three words that I heard very clearly. "Ready, Set, Go!" And the most amazing thing happened. I began to move. And I kept moving. My breathing became a little more relaxed, and when I looked around I saw Merry and Jan and one woman who looked twice my age riding an old bike with a wire basket on the front handlebars. I felt my confidence coming back as I waved good-bye to my husband and said, "Hello, dream" silently to myself.

That feeling of calmness lasted for only a mile because the day proved to be extremely demanding. For the next two weeks I was emotionally and physically miserable. I was slow and exhausted from biking an average of 85 miles a day and depleting every morsel of energy biking over steep, mountain passes. Drivers passing by in their cars must have looked at me, the rider sucking air with the bulging veins in her face and neck, and wondered if I would make it up the mountain pass as I strained to stay balanced on my bike going two miles an hour. Going uphill was incredibly grueling, but flying downhill on windy, pitted roads was terrifying. Even when we had relatively flat sections to ride, the head winds slapped me around leaving me defeated and more weary than the constant climbing. At the end of the day, I was exhausted yet happy to get into camp, but

my happiness was always destroyed when I realized everyone else was finished with dinner and already thinking about going to bed. I hated feeling weak and less than the other riders, but the most damaging feelings came from sensing everyone else saw me that way, too. I despised the other bikers constantly passing me on the road and was jealous of their physical gifts that eluded me. That jealousy fueled my annoyance as I continually asked with disdain, "What Am I Doing Here?" Day after day I would ask that question and shift from gear to gear struggling to get where I needed to go.

One morning I woke up and something had shifted. I felt a slight change in attitude. I sat up out of my sleeping bag, unzipped the pup tent and poked my head out in the cold watching everyone scurrying around. I shook my head and wondered why I was not satisfied with my own pace and why I couldn't let go of other people's opinion of me. I yelled to Jan and Merry, "I'm sleeping in this morning. I'll catch up with you later." I snoozed for another half hour then took some extra time packing up my tent. Instead of racing to get out on the road early just so I would not be the last into camp, I ate a leisurely breakfast of waffles smothered in butter and maple syrup and met some new riders that always left after the early rush.

I moved with a deeper sense of relaxation, strength and awareness as I pedaled solo up a long two-lane winding mountain road. It was a gorgeous cool Montana morning with purple mountains to my

right and sloping plains to my left and the big blue Montana sky everywhere. I connected with the stillness of nature that day, completely surrendering to its sacred sounds and sights. Nature rested within me and I was beginning to feel downright gleeful. Suddenly, I heard drumming as if the earth was reverberating its mantra and welcoming me back to life. I began to sing, first softly, then louder and louder as if I finally was letting go of my expectations of the bike ride. "Come, they told me, pa rum pa pum pum...to see the new born king, pa rum pa pum pum. I have no gifts to bring, par rum pa pum pum...to set before the king, par rum pa pum pum, ra pa pum pum, ra pa pum pum."

All of a sudden, a tidal wave of clarity exploded up from the bottom of my feet and surged through the top of my head and I *froze*. I stopped riding, unclipped my feet from the bike pedals, planted them firmly on the ground and threw my arms in the air. I finally got the answer to my question. I knew why I was I was on this bike ride, and why I was living this life! I knew! I had been asking, "What am I doing *here?*" not "What am I doing on this bike ride?" and this bike journey, every excruciating mile of it, needed to happen so that I could live this moment in time. When you ask a question you always get an answer and mine was found in one of my favorite Christmas songs. When I sang, "I have no gift to bring," my heart broke realizing that thousands of people go through life believing they have no special gifts to offer mankind. That is exactly

how I was feeling every minute, every day on this ride. Unworthy! I never wanted others to feel that way…ever. Then my heart OPENED completely like it had been waiting to do so all my life. I knew I was here on this earth to honor my gifts and inspire others to know and share theirs. A little black bird perched on a wooden post across the road looked at me in my moment of discovery and together we just nodded. I have never felt more connected with the earth, air, animals and my heart than in that sacred moment.

Then I bounced back on my bike and pedaled across the Wyoming border. Just as I entered the new state, a dream appeared in full, magnificent, glorious color and detail. It was an old dream of starting a theatre for women and girls. I had buried that idea and left it for dead years ago. But today was a bright new day, so I dusted it off and began my plans to accomplish it. As I pedaled across the United States, at my own pace now, that new dream and my new attitude carried me all the way into Washington D.C. August 1, 1998, I was one of 600 cyclists that finished…and I had only had one flat tire two miles from the Washington monument. I thank God and my mother, who said a rosary for me every day, for allowing me to be there. The journey changed my life forever.

Back in Tampa, it was time to act on my dream. Now, the real work began. I got back to my morning routine of sitting outside, but now I carried a writing pad and spent hours capturing plans to begin

Powerstories Theatre. It would be a theatre staging true stories of amazing local women and girls. We would perform our own powerful stories locally, nationally and internationally, always with the intent of opening minds and hearts and inspiring others to live a life of passion.

Periodically as I wrote, I would throw my head back and openly laugh at how joyous and grateful I felt for being given this incredible dream. Sometimes I would just shake my head in disbelief, remembering how fearful I was in years past about starting a theatre. It had been a huge dream of mine after I graduated from college. Fear froze me back then. I was so frightened of what others would think. So afraid of failure and of being criticized. So unsure of my own worth. The bike ride changed all that; I was no longer afraid.

Several months later, a group of forty women came to my first Powerstory Theatre Open House in a small studio on the third floor of an old cigar factory in West Tampa. I shared my dream and simply asked them, "Do you have a story to tell?" Seven amazing women, most without any stage experience, were selected to perform in our first show "Let the Stories Move You." For eight months we wrote and re-wrote our stories, memorized lines from the script I wrote to link our lives together, and learned to sing and move on stage. The hour before we performed, that old feeling of fear started to rise in me. What if no one shows? What if the audience doesn't laugh or applaud. What if no one likes it? But the

one question I did not have to ask was "What am I doing here?"

All my questions were answered that November night in 2000. We heard laughter when 70-year-old Angela talked about catching snakes in the Everglades to earn extra money for her family and we experienced silence when Lisa spoke of her brother Scott's life then asked, "Are you living a life that is juicy and flowing?" Our collective spirits were joyous when we sang "Step Outside Your Circle and Listen to the Song of Your Heart," and we each felt honored knowing our stories were shared to open minds and hearts.

The next morning I gave myself an extra hour to sit outside and sip several cups of hot coffee and be with nature. The oranges were ready to be plucked, the azaleas were blooming unseasonably for a second time, a single bird was chirping overhead, an insect was humming somewhere, and the pups were springing across the grass looking for lizards. I rested there at home, breathing deeply and observing nature in all its glory with the unshakeable serenity that came from finding my passion and my life purpose.

Fran Taylor Powers, M.Ed., is Founder of Powerstories Theatre, which stages true stories of women and girls to open minds and hearts. The inspirational theatre performs for the general public, at retreat centers, national conferences and colleges. Fran is also a motivational speaker helping others to "Seek Your Passion" and to "Seek and Speak Your Story." One of the topics Fran discusses is the importance of dreaming big. Fran recently accomplished two big dreams of cycling across the U. S. and starting Powerstories Theatre. Fran lives in Tampa Florida with her husband, two stepchildren, and two Dachshunds. She is here to serve you.

Oh, Yes I Can!

Angela Martinez

I was fourteen when I slipped off my rather privileged plane in society. It was the summer of 1942, and I had lived in a beautiful home, wanting for nothing. When my father left…it was all gone. We became poor for the first time. My distraught mother was too depressed to supervise us. I was free to fly where I would. After the first weeks of confusion, my life became a struggle for survival and an exciting learning exploration. For the next four years, I threw myself in front of every opportunity for adventure and excitement that came speeding my way.

My mother moved our fractured family, my two sisters, my brother, and I, from Michigan to Florida. When we first got there, we had few resources, and

had to try all sorts of enterprises to keep food on the table. My twelve-year-old brother and I took on a three-hundred-customer paper route. Neither of us had a driver's license, and we were equally inept at driving, but since I was the older, I drove. We supported our family, until my mother found work after a prolonged period of depression. For extra money, my brother and I captured poisonous snakes in the Everglades to sell to serpentariums. I also worked in a drugstore after school, among many other ventures. By the time I was sixteen, I was earning almost enough money to take flying lessons. If I couldn't afford an hour's lesson on Sunday afternoons, I would fly for a half hour. Occasionally, I would have to miss a lesson, but I learned to fly. Although we were still poor, I realized one of my dreams.

In the summer between my junior and senior years in high school, I became a flight hostess (that's what we were called back then) on a Puerto Rican charter airline. There were no uniforms; I was told to wear whatever I thought was suitable. Well, I had no idea what was suitable! I had never flown in a passenger plane. I had never even seen a flight hostess. I made a bright yellow skirt out of a remnant of material, and a white silk blouse out of an old parachute. That's what I wore on my first flight to New York. Before take off, the pilot briefly explained my duties and that covered my training.

No one questioned my age. Not even when I piloted a DC-3 (with passengers on board) down the

East Coast of the United States one night, when I hitched a ride back to Miami. The pilot wanted to spend some "quality" time with the hostess working the flight that night, and the co-pilot was either dead tired or very drunk, because he was passed out in his seat.

When school started again, I had to quit flying, because I was missing too much school. My mother remarried and I didn't have to work the rest of my senior year. After I graduated (as valedictorian), I ran the skating rink that my mother had bought, and taught dance skating. Mother's marriage lasted less than a year, and we were once more without money. I saw a fascinating ad in the newspaper for young women to run powerboats and take tourists on thrill rides. Just up my alley! Never mind that I had never run a powerboat. I could do it, I was sure. I applied for the job and was hired. I was told that I needed a Coast Guard pilot's license, so I bought a pilot's instruction book, studied it, and passed the test. There was one more hurdle: I needed to learn how to run the boat without the boss discovering my total lack of experience. I told him I wanted to familiarize myself with his boat, so he handed me the keys, and in one afternoon I taught myself how to run it. I didn't know if I would ever thrill the passengers, but it sure scared the heck out of me.

By the time I was nineteen, I had accumulated five hundred dollars. I bought my first house: a little, ramshackle, white frame house in Hialeah, Florida. It was really cheap because it was con-

demned. It had no bathroom…I would build one. I built a bathroom on the back of the house that sent the building inspector into gales of laughter, and me into tears. As I sat on the edge of the bathtub crying, he said, "There, there, little girl. Don't cry. I'll come back after work and help you straighten this mess out." And he did. We now had a bathroom, and my family moved in.

My building experience continued to grow little by little. I learned to plaster walls. I learned not to stuff newspaper into an electric wall receptacle to keep the hot wires dry, and then plaster over it with wet plaster, especially while standing on a wet concrete floor. I learned to pour a concrete patio floor and trowel it to a smooth marble-like finish. I learned not to use a metal trowel on a wet patio floor during an electrical storm. I learned to wire houses. I learned that it is probably a good idea to stand on the arm of a chair while wiring (even if I could have afforded a ladder, which I couldn't) because when I cut into a live wire, I was catapulted off the chair, breaking the contact, and I wasn't electrocuted…just a little frizzled. (I haven't *always* had curly hair.)

We still needed money for materials to continue the repairs on "this old house," so I started flying as a stewardess with National Airlines (a real scheduled airline with uniforms and training). I still bought, repaired, and sold old houses, but for the next ten years, from 1949 to 1959, I traveled all over the world.

Flight Hostesses couldn't be married back then, so I traded that exciting, but low paying life for twenty years of comfort. Well, as comfortable as one can be with four kids who came in quick succession. But once again, I enjoyed security, comfort, and money. Gone were the years of struggling to survive. When my husband, a pilot in the Marine Corps, served as a Presidential pilot, we were invited to parties at the White House. The other pilots' wives and I were invited to tea with Lady Bird Johnson. It was enjoyable, but you did have to conform. Hats and white gloves! You didn't go anywhere without white gloves. You didn't go anywhere without your mink stole, or entertain without your silver tea service, either. It was the Grace Kelly era.

We were stationed in many beautiful places: California, Hawaii, Virginia, and North Carolina. During that time, I learned to sculpt and discovered I actually had a talent for it. I did many art shows, had much recognition, and life couldn't get any better.

Then, WHAP! There went the comfort, the security, *and* the husband, and we were poor again. Being poor at fourteen was exciting. Being poor at fifty was scary. There was a lot more stress this time. I had the responsibility of four children, and I was coping with anger and depression (albeit, not very well). Sometimes scary is good, though. It aids circulation. You need that, as you grow older. Your

heart is pounding so hard! Thomp! Thomp! It must be doing something constructive.

Eventually, scary subsided enough for creativity to kick in. I volunteered at the Women's Survival Center to teach other displaced homemakers how to be carpenters. They learned how to change their environment and take charge of their lives. Money was scarce for all of us, so we formed a work co-op and repaired each other's houses. We learned that there wasn't anything we couldn't do if we set our minds to it. After all, another human being had built the house in the first place, so we could certainly rebuild or repair it. It was one of the most rewarding things I had ever done.

When the court ordered child support and alimony didn't materialize, I realized that I would have to find a paying job. With so much talent waiting to be tapped, the creative director of the Center obtained money through a grant for home repairs. I was hired to start a program called SHIP (Senior Home Improvement Program) to repair the homes of the elderly poor, so they could remain in their homes and not be institutionalized. I hired displaced homemakers, because women learn fast, are good at what they do, and are caring of the old people. It wasn't long before we were hanging doors, replacing windows and floors and roofs, repairing walls, and doing plumbing and electrical work (standing on the arm of a chair….no, just kidding). Now we used ladders and turned off the breakers before attempting repairs.

We attracted a broad spectrum of attention: from the mailman who thought we were women prisoners sentenced to do this dirty work to national and local television. We were filmed by the *Today Show* (twice), *Good Morning America, Attitudes, World Monitor, Senator Chiles's Update*, ABC's *Home, Modern Maturity TV*, and dozens of local broadcasts. Becoming somewhat comfortable with camera crews filming while we worked was one of the hardest things we had to do, much harder than roofing a house.

As I reluctantly approached sixty (the age of power, my twenty-year-old daughter told me), I was invited to do a home repair segment on Channel Eight's *Time Of Your Life*, a weekly show aimed at an older audience. Whoa! I knew nothing about doing a real TV show! Being interviewed on a job-site is one thing, but putting together a real show is something very different. At first I declined, because of scheduling and apprehensions, but it is interesting how one thing leads to another, if you are open. I had learned a euphemism for "panic stricken," it's called a "challenge." So, whenever I'm challenged, I say, "I can do that," kind of nonchalantly like I really believe it. But a nasty little voice deep inside always says, "Oh, no you can't." "Well, don't tell *me* what I can't do," I bristle. *"I'll show you!"* The show ran for four and a half years, with many bloopers and blunders, perhaps the worst of which was when I blew up the set while demonstrating fire

extinguishers. The disasters may have been what the audience enjoyed most.

I was still running the SHIP program when I retired at the age of seventy. We had made more than seven thousand repairs, and thousands of elderly people were still able to remain in their homes. That wouldn't have happened if I hadn't had the opportunity to be poor, and if God hadn't given me so many training opportunities and pushed me in the right direction. I thank my Guardian Angels for keeping me safe. That's plural because I feel like I may have worn out more than one angel over the years.

Now after all these years of searching for security, I have finally discovered there is no such thing. But I'm comfortable right now, and I have time to sculpt, write, and travel. I wouldn't voluntarily give up my comfort, but once in a while I wonder…will I become poor again? And if I do…what creative, exciting, new adventures are waiting out there for *me*… to say… "I can do that!"

Angela Martinez is a sculptor by profession whose works may be seen in churches, libraries, professional offices, and private collections. She created and ran a nationally recognized home repair program for the elderly in Hillsborough County, Florida. She is a world traveler and lover of adventure – a love that she shares with her four grown children. Angela received the *Amigas* award from the Women's Peacepower Foundation for her work with and dedication to women, and has been named a Paul Harris Fellow by The Rotary Foundation.

Don't Blame The Road

Rose Bilal

When I was a ten-year-old kid, I wore three braids, one on top of my head and the remaining two on each side of my ears. My quirky and questioning personality fit right in with my hand-made cotton ruffle dresses and cocoa brown skin. My world was all play and full of fun. I never once doubted it was also safe and secure. It was during this time of innocence I found out there are a lot of men out there who want to make little girls the object of their sexual fantasies. I mean I literally had to run for my life from almost all the men who were around me. They were either trying to put their hands up my dress or crawl in bed with me while I was asleep. These were the same men who I depended upon to protect me. They were my cousins, uncles, and friends of the

family, the minister of my church, even my own
father. As bad as it was that my father was someone
I had to run from, the fact that my minister would
want to molest *me*, a little girl, affected me the most.
I mean I had him right up there with **God**. When I
sat in church on Sundays listening to him deliver his
fiery sermons, I wondered why he wasn't afraid that
God would strike him dead. He not only hurt my
soul, he helped give me a low opinion of myself and
a false understanding of right and wrong. In my "lit-
tle girl thinking," I made myself believe that men
did those things to me because I was a girl and I had
to wear a dress. So I decided to become a tomboy
and I refused to wear a dress, except to school and
to church on Sunday. I definitely would never be
caught dead playing with my dolls!

My poor mother didn't know what to make of
my silliness and absolute refusal to have anything to
do with being a girl. She did become concerned
when I became a teenager and was still refusing to
wear a dress, and wasn't showing any interest in
boys the way my girlfriends were. My mother didn't
know the reason I chose to reject my femininity. I
never felt close enough to my mother to be able to
tell her about being molested, nor did I think she
would believe me. I lived with the dreaded secret
and continued to cope my way.

One day, when the doctor came to our house for
his annual visit (back then doctors made house
calls), I was coming out of my bedroom when I
overheard my mother asking Dr. Panza if he thought

I was gay. When I heard those words coming out of my mother's mouth, I stopped dead in my tracks, with jaw dropped and eyes *stretched.* After the shock of hearing this, the only thing going on in my mind was, "If my own mother thinks that I'm gay, then maybe I am and I just don't know it!" So to prove to myself as well as my mother that I *was* a woman, I went on a mission to seduce Johnny. Johnny was by far the handsomest boy at school, and he had the coolest walk I had ever seen. I told a mutual friend to get Johnny to ask me to the Saturday night neighborhood dance. He did, and we did "it." When it was over I wondered why I hadn't heard violins playing beautiful music or seen color-ful fireworks exploding against a black night sky, you know, like in the movies. How come nobody ever told me about *the pain*? Well, I was fifteen and very naive. I also had no knowledge of what hap-pens when you have unprotected sex. Needless to say, I was sent totally into orbit when I found out a few months after my big night of self-discovery, that I was pregnant. I mean, I couldn't believe it! How could I be pregnant? I only had sex one time, and it wasn't even in a bed. We did it on the cold basement floor! But I was pregnant.

It was a difficult pregnancy. Not for medical reasons, but because my parents were so disappoint-ed and embarrassed by my indiscretion that they refused to talk to me. They would barely even look at me. I found it hard to believe that my dad had the nerve to be embarrassed. I did not know then it's

what is made public that causes embarrassment and, to make matters even worse, I refused to marry Johnny. My parents didn't force me to do it, but it didn't help our relationship. I pushed them even closer to insanity by also refusing to follow an old church tradition of apologizing to the congregation for my sins - the congregation led by a minister I did not respect. They were so desperate for a way out of their "undeserved" nightmare that they took the advice of my aunt who told them where they could buy pills designed to get rid of unwanted babies. I thought my mother had finally accepted the situation and was just being nice to me when she handed me the pills and told me to take them. She said they'd make things better.

Nothing happened right away, but when I was in my seventh month I became violently ill. We found out in the hospital emergency room that toxic poison had flooded my entire body. They were forced to induce labor and I underwent one of the worst experiences in my life. The trauma to my system had caused the baby to turn and start coming out feet first. When they couldn't get the baby's head out, the doctors realized too late that I should have had a cesarean. They had no choice; the only thing left was to get him out by using forceps. They saved my life, but my son didn't make it. The worst thing was, instead of being heartbroken, all I could feel was relief. What would have been a horror story for any mother had been the answer to my prayers. I was too young to be a mother. I dreamed of being a

good mother as other girls did, but I was too young to know how. How would I protect, care for and love a child without support? Even though I knew the words were true, I carried guilt for a lot of years for having such thoughts.

On the way home from my tragic hospital stay, my mother told me that she and my father were sending me to Philadelphia to live with my Grandmother. They hoped this would keep me out of trouble until I finished high school. Boy! What a big mistake that turned out to be. I was enrolled at a girls' high school, which was right next door to a boys' high school. All the students ate lunch and hung out at Tony Meatballs, the deli up the street. It was there that I met Earl "Goofy" Cook. He got the nickname because he had lost part of his foot in a trolley car accident and he walked with a limp. He tried to walk cool so nobody would notice the limp. Goofy introduced me to the world of crime. Goofy and I and the guys we hung around with would steal cars, hold up service stations, and buy and sell stolen goods. We even planned and carried out the armed robbery of a finance company.

And yes, as to be expected, after about a year we all ended up in prison. I had been given a two-year sentence. But when they locked those long steel doors behind me, I had my "light bulb" moment. As I heard the doors slam closed, I realized in a flash that I was in charge of my life, but I had been giving my power away. I never contacted my family nor did they know what I had been doing. As I sat in my

cell during those long, lonely nights, the only place I had left to go was within. During this time, I found out that prayer really works.

One day a guard came to the laundry room where I was assigned to work and said he had orders to take me to the warden's office. That was never a good thing. You didn't go to the warden's office unless you were in deep trouble. When I sat down, Mrs. Wolfe said to me, "Rose, I have been the warden at this prison for a lot of years and I know the people who belong here and the ones who don't. I don't believe you belong here and I've arranged with the judge to allow you to do the remainder of your sentence out on parole. You will be released in the morning, but if I ever see your face here again, I will act as if I never knew your name." I didn't know whether I should kiss that stern-looking, white woman or get mad. I knew the staff would sometimes play cruel jokes like that on the prisoners. That night in my cell I didn't think daylight would ever come but when it did, after serving only six months of my sentence, I was set free.

That day I promised God, The Warden, and myself that I would never allow anyone to take charge of my life again. I would only do things that made me happy. That philosophy has become my blueprint and I will wear it out. It has taken me through several broken hearts and out of an abusive relationship. Today I'm a successful jazz singer, performing with many well-known entertainers locally and abroad, an award-winning visual artist and

sculptor, an actor appearing in many plays and industrial films, a writer working on my second book, and a professional speaker. Whenever I'm invited to speak to young girls who find themselves in a situation like mine or worse, I always tell them to never let fear stop them from walking away from any situation that does not feel right in their souls. I was afraid to tell my mother or anyone close to me that I was being molested. As a result, I set myself up for a lot of the bad experiences that followed. I also tell the girls to never allow themselves to believe that they have to have a man in order to be a "complete" woman. If they will learn to believe in the power they have within themselves, no one will ever be able to abuse them or rob them of their joy. They will know that *every* experience is an opportunity to learn and to grow spiritually.

I sometimes find myself almost looking forward to my next challenge or experience. I know with each that I am given another opportunity to learn. With learning comes knowledge; with knowledge comes joy and freedom. I have both!

Adapted from *Don't Blame The Road,* a memoir by Rose Bilal.

In a long and varied career, **Rose Bilal** has done
it all. A singer, an actress, an artist, Bilal is above
all an entertainer. She reaches across a stage, or
from the other side of a canvas, and engages her
audience with the force of her personality. Her
singing, like all of her art, is infectious, joyous
and always surprising. She has worked with
some of the greats: The O'Jays, The Delphonics,
Wilson Pickett, Dee Dee Sharpe and Gladys
Knight & The Pips. Now based in Tampa, Rose
is at her best on stage in a nightclub or cabaret,
where there is nothing between her and her audi-
ence but love and music.

Power Within

Afsaneh Noori

Yekee bood, yekee nabood, Ghair-as Khoda, hish-kee nabood. In the Iranian language this means: One was, one was not, other than God, there was no one. This is how all fairy tales began in Iran. I want to tell you a fairy tale about my life. I was born into one of the oldest and most influential families in Iran. I was the only daughter, born years after two sons to my now-older parents. They named me "Afsaneh" meaning "Fairytale." Since my last name, "Noori," means "Light," I became their "Fairytale from Light." My family was wealthy, well traveled and educated...giving me opportunities that were unheard of by most little girls in Iran.

My father Ali, whom I called Baba, was a general in the army of the Shah. He was a gentle and

loving man. I absolutely adored him and there was nothing I wanted more than his attention and approval. Baba encouraged me to be independent. The summer I turned 14, he taught me some of the most important lessons of my life. That year, he was building a summer home by the Caspian Sea in northern Iran. Every weekend, he drove to the new house to check on the progress of the construction. I loved to tag along with him each weekend and enjoy his complete attention. He would tell me of his hopes for me and his fears about me growing up in a country that suppressed women. He would often say, "Afsaneh, I was both happy and sad when you were born. Happy...because God finally gave me the daughter I wished for. And I was sad because the laws of a Moslem country are not in favor of women. They are designed to keep women subject to men. That...I do not wish for my daughter. Listen to me, if you don't want to be suppressed you have to be able to take care of yourself and your children financially. You have to always keep your options open and never have to depend on any man. The way to be independent is to be well-educated."

My mother Nahid's teachings were much more subtle. Maman, as I called her, taught me so much by the way she behaved, which was so different than most other woman around us. Maman was a "classy lady"...an intelligent, open-minded, modern Iranian woman. She was trained in the proper etiquettes of her time, but that never stopped her from pushing the boundaries when she needed. In fact, one of our

family legends is about my mother's persistence in sending her two older sons to the United States for college. Baba's family was afraid that these first born boys would adapt to the American way of life and might never return to Iran. But Maman told him, "I know that this will be a hard sell to your family but the future of our children is more important than any of these concerns. Kamran and Abbas will have opportunities in America that would never be available to them here. If we love our children we have to give them what is best for them." And this was enough to convince Baba. He told his family that this was their decision...the boys went to America and...they never returned!

My parents nurtured my spirit to be free even against the odds I would face as a woman in Iran. Then it is not surprising that one of the greatest challenges of my life became the pursuit of freedom and the search for the true source of my power. You see, as a young woman, I learned to identify power with control and saw it as the privilege of men. And, I believed that if I could find a way to enter that circle of influence, I would find freedom and forever would be safe from suppression.

Having been raised as an independent thinker, I had no concerns about falling in love with a young man from another faith, with a drastically different family background from my own. I believed I was allowed to choose my husband. But when I did, I realized that I could choose only as long as he matched certain criteria set by my family. Marrying

an Armenian man was even beyond my parents' boundaries. They could see the heartache we would face, when both groups would reject us. Their solution to save me from that fate was the great sacrifice of selling all their belongings and taking me away to America when I was twenty years old. I left Iran in tears. The first few months were very difficult for me, but soon I realized that America gave me choices beyond my wildest imagination. I chose to become an engineer. This was that great doorway to the world of men... to the world of power. I did well in school and graduated with honors. My resume was impressive enough to land a great corporate job a few months before my graduation. The same week that I graduated, I also became a citizen of the United States. Now I was ready to begin my new career and my new life of freedom. I felt successful and accepted in the circle of men. I had it all.

A few years into my career, I was transferred to an engineering department where I was the only female engineer. Going to the morning break was almost a ritual with this group. They drank coffee, talked shop a little, told a few jokes and "checked out the women" as they walked by. Even though this was not the way I would have preferred to spend my break, just to fit in I would go to break with them, laugh at their jokes and check out the women as they walked by. At first, it even felt like an achievement to have them see me as "one of the guys." In my gut, I even felt a little superior to other women. After all, *I* had elevated myself to the world of men. Yet, there

was always a nagging feeling inside me and I could not dismiss the discomfort of acting like men.

One day in particular was a life-changing day for me. I was laughing at yet another off-color joke when I had a sudden insight: I realized that in order to belong with men I had rejected my own gender. As if seeing myself with new eyes, I had to ask, "Who am I? What am I doing here? This certainly could not have been what my parents were trying to teach me. They never told me to FORGET that I am A WOMAN!" It was then that I realized that I was not a success, only a successful fraud.

Clearly, now it was time for me to define *my own meaning* for success and power. I had bought into an illusion. I had believed that success was achieving the "American dream." Even though I could now check off everything on that success list, I could no longer find my self anywhere. I needed help and I sought that help in therapy. I spent hours reading, thinking, drawing and writing in my journals. I had to find my own truth and then I had to learn how to live that truth.

It seemed like never-ending years of asking questions, but the fog eventually lifted. The deeper I looked into my inner self, the closer I came to an unexpected spiritual clarity. I came to believe that I was one with God and all creation, and that love was my connection to "All That Is." I learned to trust that no matter what it looked like at any given time, "All is always well" and I have nothing to fear. *I became a believer that I was here for a specific rea-*

son and I was part of a greater plan. I learned to follow my truth and energy wherever it took me and to trust the natural talents and gifts I have been given to fulfill my purpose in life. And... that became the foundation to build my new life.

Eventually, I left the company I was working for and the field of engineering. I started my own consulting business and specialized in organizational transformation. The next five years were a roller coaster of change and evolution, both in my personal and professional lives. With every up cycle I was reassured and knew without a shadow of a doubt that I was on the right track. But each down cycle filled me with fears and self-doubt, wondering, "What have I done to my life?"

One time in particular, my finances were so bad that I was ready to let go of everything and run back to the security of employment. One day, I told my teenage son, Adrin, "I know this is hard on everybody and I am thinking about working for someone else again." Adrin paused and then said, "You know, Mom, I thought about that too, but then I thought, that is not really you!" I saw that my son had learned from me as I had learned from my parents. I had passed on my beliefs to him and now I had to show my courage and stay true to those beliefs. I hung in there and soon the low cycle ended. As I went through each cycle of life, I learned something new, until I finally understood that life would always work in cycles. The only things that I had any con-

trol over were my own perceptions and attitudes towards events.

A few years ago, I had an opportunity to visit China. Before I left on this long trip, I bought myself some metallic gel pens and black paper to doodle when I got bored during the flight. I found an unexpected joy in creating colorful, shiny shapes that would pop off the black paper. I found myself taking my pens and paper everywhere and drawing every chance I got. Drawing was so much fun that when I came back to United States, I bought even more colors and larger paper to work on. I spent hours drawing and finished a new piece every few days. My mother, who was my greatest supporter, kept asking me, "Honey, you are a talented artist. What are you going to do with these drawings?" I would say, "I am just having fun, Mom. If God wants me to do something with them, She will put someone on my path that can tell me what to do." Meanwhile, my self-talk was, "Of course my mother thinks I am an artist, but I am really just a good doodler." After all, I had no qualifications to call myself an artist!

The Universe did have other plans for me, however. Within a few months, I met a woman who had just started an organization called Women Artists Rising with the purpose of supporting women artists in the Tampa Bay area and creating venues for them to show and sell their art. I got so much encouragement and validation in the first meeting that before long I became a regular at all their functions. The

power of having so many talented women artists gathering to support each other was such a boost for my self-confidence. We would bring our latest work to get feedback and talk about different techniques or give each other information on the best place to get art supplies. We connected each other to different resources and the next art show that was coming up. With their encouragement, I soon expanded to other mediums and my work became even more elaborate. As I grew in my art, my paintings began to show the influence of my Iranian heritage and reflect my core spiritual beliefs. In less than three months, I had my work hanging in galleries and art shows. People's reactions to my paintings were very positive. Selling a couple of pieces of my art was the beginning of recognizing myself as an artist and embracing the hidden talents that I have been given. This incredible group of women helped me to appreciate the quiet strength of my gender and value the depth of my upbringing.

Throughout the years, I have discovered many answers to my questions about life. I can see things more clearly now even though there are always new challenges to face. I can, at last, look into the mirror to see and value myself for who I am because I am finally living my life with authenticity. It brings me joy to hear my mother say I have become the woman my parents hoped and sacrificed so much for. Even though right now I am transitioning into another cycle of life, I continue to feel a deep sense

of gratitude and I am at peace with my world and myself.

Sometimes I wish I could shout for the whole world to hear: "True power has nothing to do with being controlled or controlling others." We are all here to live our lives and to learn from the process until we remember that Light and Shadow come from the same Source. I no longer expect my life to be trouble-free. In fact I know that as long as I live, I will always be challenged by events that would make me choose over and over between closing myself in fear or opening myself with love. But as long as I can remember that freedom is my birthright, that my heart is my guide, and that my values are the compass for my choices, I can summon up the power of love and compassion, my only true power, my power within.

Afsaneh Noori was born in Iran of two daring and devoted parents that named her Fairytale (Afsaneh), contrary to the Moslem tradition of naming children after religious figures. Afsaneh has never followed tradition for tradition's sake and encourages us with her example to be ourselves even if it is not popular. Afsaneh has used her personal changes, challenges and loss as tools in developing her spiritual values. In the process of spiritual growth, she came to understand that her life and work were one and the same, bringing her light into her professional life with joyous results. She believes that her roles as an organizational transformation consultant, visual artist, author and storyteller are only satisfying when they embody her values.

Scott

Lisa Shannon

Waeveus

Yesterday,
While exploring a path which led me far from home
I came upon a name
carved deep into the bark of an oak.
Old, twisted and scarred,
someone named John
must have been here long ago.
The testament brought back memories
of broken fellowships
brothers and sisters lost or strayed-
did they sometimes reach back into
the days we spent playing by the lake
or to a time when we happened to discover one another?

I followed the trunk upwards through its countless,
branching arms
and wondered
what it would be like-
to be as strong, and dignified and firm as an elm or maple
to be able to hold on to a piece of the earth.
But only memories take root.
I hope one day others will stand at a tree which
bears my name
that it grows tall, and broad
and that the seeds I have planted
have sprouted in good soil.

-Scott Wilde, 1985

There is a tree growing up the side of an overlook
where eagles soar by, and the snaking of the river
makes lazy "S" shapes below. The wind blows
through, yet there is silence. This is the place where
my brother's ashes lie, buried under that small pine.
This is a sacred place of childhood dreams, of
adventuring in the woods, of learning to trust nature.
This is a place where I go to when I need to remem-
ber.

From my earliest childhood memories, I always
felt I had someone watching over me. I am the
youngest of five children, born and raised in a north-
ern town in Wisconsin, but it was my older brother,
Scott, who had the same thoughtful brown eyes as
my own. My mother said when I was born, they
returned home with me from the hospital and placed

me in a bassinet, and it was Scott who stood guard making sure none of my other siblings bothered me or made me cry. And it was Scott who never tired of playing king of the raft with his little sister in the lake each summer, for hours. He didn't seem to mind me tagging along with him to chase golf balls as he practiced his drive in the park near our house. Most of all, it was Scott who taught me his love of nature. He taught me that the woods, the lakes and everything in and around them were special places to discover. The woods brought an unmatched inner peace and strength and just walking in them made you feel so strong and alive. Often he would set out in the morning for a long hike in the sweet green woods only to return late in the day with a walking stick in hand. This was a nearly perfect day for him. I, too, followed and discovered my own north woods adventures among the pine and moss covered rocks. I was never afraid, because I always knew what Scott could do, I could also do.

And how he loved a thunderstorm! He would sit out on the railing of the front porch of our house, his arms extended upward, his face drinking in the rain while the thunder and lightening clapped above. But I stood behind the front screen door trembling and marveling at his bravery. He was determined to live a life that he called "juicy and flowing." And this wasn't always easy for him, since there is one important thing that I must mention about my brother. When he was just eight years old, he contracted diabetes. He had to learn to give himself shots of

insulin twice a day. He practiced by poking the needle into the skin of an orange, not an easy thing for an eight-year-old boy to do. Along with the insulin injections, he had to be very constricted to what he ate. When all the other children ate cookies and candy, Scott wasn't allowed. When they swam in the pool in the hot summer and went for an ice cream cone afterward, Scott wasn't allowed.

As time went on, Scott struggled to be like every other teenager. He wanted to stay up late, eat what everyone else ate and to just be like everyone else. But when he was just nineteen, this caught up with him and his vision failed. He had to have laser beam treatments on his eyes, which left holes in his vision. He couldn't hold a job. He couldn't drive. But it didn't stop him from doing the things that he loved most, such as studying medicine. He worked long hours peering into the microscope. He listened to books on tape, and carved beautiful wooden dolls, boxes and frames for everyone he knew. It didn't stop him, either, when he had an opportunity to travel abroad to study for a semester in Malaysia in his early twenties. Traveling that far away was against the wishes of my parents and the doctors, but Scott was determined to go. In fact, something was driving him there, something that I don't think he even understood. He did go to Malaysia with his class, but in true, unpredictable Scott fashion, he dropped out mid-term and set off for a deeper exploration. He traveled by foot and by train into the back country in India. He met spiritual people and stayed with

them in their grass hut villages. Scott became close to one healer who encouraged him to stop taking his life-giving insulin, which he did. He went without it for over a week and was unaffected.

Late that summer, when I was just starting high school, I was looking out from our second story bedroom window and saw a figure approaching in the distance with a backpack and a walking stick. The sandy blonde hair and ragged red beard were familiar, but they carried with them the scent of the ancient land from which he had returned. My brother was back, but such a different man. From that moment on, he became the man I remember most – enlightened, kind, and more patient than anyone I have ever known since. Why, on his birthday, he gave everyone else a single rose to commemorate the day. "A birth day," he would say with that sheepish Scott grin. It was Scott who taught our family, by his example, how to say, "I love you" to one another and to hug each other when we came and went. These seem like simple things, but not to a stoic, Norwegian family like ours! We shared many long conversations together, and I found that talking with Scott was always a treat. The older I got, the more I cherished my time to see Scott when I was home visiting from college or my summer job in the north woods.

But as time passed, Scott's diabetes grew worse and he had to have insulin injections three times a day. His kidneys failed and he was placed on a long list of donor transplant patients with the University

Hospital. While he waited for a donor to be identified, he went to a clinic in our hometown three times a week for dialysis treatments to purify his blood, which poisoned his own body. It is a grueling and exhaustive process for all patients, but Scott took each visit as an opportunity to lighten someone else's load. He would tell jokes to the nurses, put on a clown wig to make the other patients laugh and do just about anything to make someone else happy, because everyone was a friend to Scott.

I was living alone in my first apartment just out of college in Madison, when a fateful call came in the middle of the night. A lumberman in Michigan had died a few hours before as a tree fell on him and he had been identified as a perfect donor match for one kidney and a pancreas for Scott. Scott had to be rushed two hours away to Madison from our hometown to prepare for the transplant operation that had to be performed within seven hours of the donor's death. There was no time for decisions. All the decisions had been made. He told my family on the way to the hospital only that if something happened, he would like to be cremated.

I met Scott and my family at the hospital in Madison and I held his hand before they took him to surgery. There was great excitement and relief in his eyes as he winked at me one last time. He had the surgery and not only that, he recovered remarkably fast! The very next morning when I returned to the hospital to see him, he was up and walking. He wheeled his intravenous stand around the critical

care unit to the nurses' station to catch up with the nurses. Within two weeks, he was released from the hospital and we met up at a restaurant in Madison that day before he returned home. We sat across from each other, in disbelief and amazement, as he ordered a hamburger, fries and a regular soft drink...not diet! It was the first time in his life he ordered whatever food he wanted. I realized that my brother was a healthy man. He returned to our hometown later that day and I giggled a little to think of how amazing it all was. But three days later his body began rejecting the newly planted organs. He had contracted something called a C-virus, which if identified, can be captured, cultured and returned to the body to heal itself. He returned to Madison to the University Hospital for tests. I walked into his hospital room with a sense of despair, only to see Scott sitting on the edge of the hospital bed staring out through the big window. He kept remarking what a great spot it was to watch a good thunderstorm, yet it was, in fact, the driest spring any of us could ever remember. No rain.

Down the hall, there was a man crying out in pain. The groans echoed through the halls day and night, yet we never bothered to do anything. I was caught up in my own hurt and worry as to what was happening. It was Scott, in his own pain and suffering, that heard the man's cries and made his way down to the room and just talked with him. He found that the man had recently had both legs amputated at the knee and missed having music to soothe

him. Scott went back to his room and asked the nurse to take the man his small radio, which she did and the crying stopped.

In the days that followed, there was quiet sadness and confusion as just after Scott's thirty-second birthday, he fell into a coma. The doctors could not locate the C-virus in his body and his organs were being rejected badly. In the week that followed, my life was a blur, traveling between work, the hospital and back home for brief, sleepless nights. The doctors finally informed us the only thing that could be done was to remove the organs in surgery and pack his body with gauze to stop the bleeding. This surgery, unlike the first, was extremely swift and within a few minutes he was in a private room in the critical care unit.

I got up that next Memorial Day Sunday and drove to the hospital like so many Sundays that year. I wondered what would be the next step, would they replace the organs in a new surgery? What if another donor couldn't be found soon? I turned the corner to the critical care waiting room only to see my family members embracing each other and in tears. Scott died just moments before I arrived. I went into his room where they had already removed the breathing tubes and wires. He was just lying there peacefully. No more struggling. I reached out and held his hand close to me, as tight as I could and I sobbed. I wanted whatever it was that made him so special to pass through to me. I didn't want to let go.

I didn't want to lose the one person who gave me so much hope in my life.

That night, a crashing noise outside shook me from a sedated sleep. I went to my tiny attic apartment window to see the most amazing thunderstorm! The crash of the thunder shook the windowpanes, the rain came down in sheets, and the wind bent the trees into arching bows. I held my breath and tears ran down my face. I understood at that moment Scott was still there and that he would never leave me. Here was his thunderstorm that he waited for.

So many years have passed since we placed Scott's ashes below a small pine tree. Perhaps it was my longing to search for a new part of me, or to run away from the pain of the irreplaceable loss in my life, but I left Madison on a long journey. I don't know if I was searching or hiding all these years, but it has been lonely until only recently when I began to write this story. Something was telling me it needed to be told and with that telling, it has freed up so much beauty and self-awareness in my life. I have now reconnected with my love of acting, bought a beautiful little house and met some wonderful people. I met and married Steve, my new best friend, and we have a beautiful daughter together. It is my turn to live a life that is "juicy and flowing." And most of all, when I hear a rumbling of a thunderstorm now, it empowers me to go on.

Lisa Shannon, a Wisconsin native, now lives with her husband, Steve, and their beautiful daughter, Isabella, in St. Petersburg, Florida. Formerly an event planner for the corporate world, her love of the outdoors and her passion for the environment have led her to her current position as Communications Director for a local environmental non-profit to help restore and preserve the beauty of Tampa Bay. Her story is dedicated to keeping others' lives juicy and flowing.

The Mighty Oak Within

A story about finding self-love

Renee Dignard-Fung

I was born to a very wealthy and notorious family in Hong Kong. My grandfather came from a banking family and married my grandmother who also came from a banking family. My grandparents owned over 30 companies from McDonald's to Thomas Cook Travel Services. My family, not unlike the Rockefellers, was always under the public eye and they were constantly being written up in the news-papers and magazines. Active in public life, my grandfather was appointed a Senior Consultant by the People's Republic of China and was even given a title by the Emperor of Japan.

My grandmother was a very busy woman. She was the Chairman for several non-profit organiza-

tions such as the United Way. She traveled a lot and always had an agenda that was filled a year in advance. When my grandmother was fourteen, her mother died and she became responsible for raising her thirteen siblings and running a household of over thirty people. Later, her father re-married his concubine and had fourteen more children. Now my grandmother was in charge of her fourteen half siblings, too. She was Daddy's girl. She ruled the household, not the concubine. This is how she developed her dominating personality.

My grandparents had built a mountainside mansion that overlooked the ocean in a very affluent part of Hong Kong. I can still see so clearly their saltwater swimming pool shaped like the letter "L". The pool overlooked the ocean and was surrounded by exquisite gardens. The servants' quarters filled the whole basement and my grandparents lived upstairs. They had five children, four boys and one girl. Their second son was my father. Every Sunday, in order to please my grandparents, the whole extended family, including my parents, brothers and sisters, aunts and uncles, nieces and nephews, would gather at their estate for a family meal, even if they hated each other.

From outside, their majestic mansion glittered with fortune. It would seem like they had it all…the dream houses, the dream cars, the Ivy League schools, the horses, the pearl farms, the titles, the fame and the prestige. Unfortunately, things on the inside were not what they appeared to be on the outside.

My beautiful and small-framed mother came from a small town in China. She did not come from the kind of wealth my father came from, but she wasn't poor either. My mother came from a different background from my father, but she shared my grandmother's strong and overwhelming personality. When she was two years old, she was traumatized when she saw her mother hang herself. Afterwards, her father re-married and had four other children. He stopped paying attention to my mother and treated her differently than his other children. He sent my mother away to live with relatives in Australia and then later to schools in the United States. As a result, my mother carried a lot of emotional scars and never learned how to process her emotions.

After graduating from UCLA with a full scholarship, my mother met my father, a pediatrician. He was going to be the knight in shining armor who would take her away from her horrible past. My father's childhood dream was to be just like Dr. Albert Schweitzer. He wanted to go and save deep, dark Africa. Well, according to family gossip, when my father met my mother, he would never have to set foot in Africa because "deep, dark Africa" had come to him all in one package: my mother. She had so much emotional baggage that he would spend his entire life trying to save her.

In the beginning of their marriage, life was great. My parents had two children, a girl and a boy and my mother got to re-create the perfect family that she never had. But my father felt that it was his

duty to set up his pediatric practice in Hong Kong so that he could take care of his parents. Things changed when they decided to move back to Hong Kong.

When they arrived in Hong Kong, my parents moved into my grandparent's huge mansion until their own house was built. I was inside my mother's tummy while she and my grandmother were forced to live together under the same roof: two head-strong, dominating and controlling women that both grew up without mothers, each used to getting her own way. Together they created many fires that could not be put out. For my mother, my strong-willed grandmother was all she needed to bring up her past. All those bottled-up feelings of hurt, blame, anger, fear and hatred came pouring out towards one of her five children: me.

When I was born, I became a reminder to my mother of all those terrible fights she had had while living with my grandmother. She never treated me like I was part of the family. During family meals, my father, mother, brothers and sisters would sit at the round dining table together while I would be in a corner watching them all eat. The servants would feel so bad for me that behind my mother's back, they would sneak a slice of American cheese with two slices of white bread to me. Each of my four brothers and sisters had their own room while I slept in the den on the sofa. My brothers and sisters went to school and after school they would have the piano lessons, the riding lessons, the swimming lessons,

etc... I was kept out of school and after-school activities and stayed at home with the maids.

My mother developed a routine of hitting me almost every day with a horsewhip. My older sister and brother saw the way my mother treated me and would copy her and hit me. My grandmother would then punish my sister and brother for hitting me and then my mother would punish me for getting them in trouble. So I became their scapegoat, caught in the middle of this outrageous and childish triangle.

In the meantime, my grandparents, aunts and uncles all had to keep their eyes and mouths closed. The year I was born, my grandfather and grandmother got knighted by the Queen of England for their philanthropic services to Hong Kong and everyone had to keep quiet about the child abuse for fear that it would ruin my grandfather and great grandfather's philanthropic reputations.

At the same time, my father was also fearful of his reputation. He was a pediatrician and he had a large clientele of foreign patients, most of whom were Americans. He could not afford for them to find out that his wife was a child-abuser. If a person asked me where I got my bruises, I would innocently blurt out that my mother was hitting me. Therefore my parents stopped sending me to school. But fearing for my safety, my father would ask strangers and relatives if I could live with them for a while. He would tell them that I was having trouble at home with the siblings. Until I was nine years old, I never lived in a place for longer than one year. I would live with strangers for a few months, go

home, get abused by my mother again and go back to another home for a few months.

My Aunt Pin was my father's only sister. She was pretty, smart and a very talented artist. A successful businesswoman, she owned a very elite international interior decorating business. When she was traveling in Massachusetts, she met and married my uncle who came from an old New England law book publishing family and moved to the United States. When she got married, my Aunt Pin and my grandparents had a huge disagreement and they stopped talking to each other.

When I was nine years old, my grandmother finally got tired of watching me get beat up while having to keep quiet and she decided to take action. She called her daughter in New York City and begged her to take me in. My aunt didn't want me to come live with her but her husband insisted. So my grandmother brought me with her on an airplane to the United States to live with my aunt. When my grandmother asked my aunt to take me in, it was the first time they had spoken in years.

My journey to New York City with my grandmother started a whole new series of challenges. My aunt would end up causing me more harm than my own mother. I was so confused because her words did not match her actions. There were so many contradictions. She would tell me that she loved me and that I was a part of her family then she'd turn around and threaten to send me back to Hong Kong to be my mother's maid if I didn't do what she said. She'd

tell me that my father was trying to kidnap me. At nine years old, I believed all this and I was terrified.

My aunt repeatedly told me that she loved me and I was a part of her family, yet she didn't want me to live with her and instead sent me away to boarding schools. Now, boarding schools have classes Monday through Saturday. On Saturdays after classes, I would take the train into New York City, clean her entire penthouse, and return back to school on Sunday. My aunt had two penthouses joined together. I would stay in one side of the penthouse and her family would live in the other side and she would keep a locked door between her family and me. When I went to her side to clean, she would have gourmet foods from around the world while my side only had canned spaghetti and white bread. It was so bizarre. I remember feeling like Cinderella. All I wanted was for her to really make me a part of her family.

Another problem that I faced was that I was an illegal alien. In my grandmother's good-willed haste to get me out of Hong Kong and away from my mother, she didn't prepare for the U.S. immigration requirements. Upon landing in New York, she simply told the immigration officials that she was taking her granddaughter on a vacation. So they gave me a visitor's visa, which expired three months later.

For her own reasons, my aunt was not willing to take full responsibility for me and did not want to adopt me. Whenever the schools would ask my aunt for proper immigration papers, she would pull

me out of that school and place me in another school.

Another challenge that I had to deal with was the question of where to stay during long boarding school vacations. In a school year, boarding schools had almost five months of vacations, and I had nowhere to go. My aunt did not want me to live with her, so I had to find a place to live. I could not leave the country because of my illegal immigration status. My aunt forced me to ask the headmaster to find me a home during those long summer vacations. I can still remember the awful feeling I would get in my stomach just having to go to the headmaster and ask if I could go live with someone. I hated it.

Some of the teachers I stayed with were foster parents. With each family, I longed for a new home. But I would never stay with any of these families for a long period of time. I wanted so badly for someone to love me and make me a part of their family that I would take care of all the kids, cook and clean, do all their laundry and just be that perfect kid. But the "perfect kid" routine actually ended up turning against me. They would come to me and tell me, "Renee, we keep comparing the other kids to you and they have so many problems...they need so much more of our attention. You're so together and mature, you can fit in anywhere. Can you find another family to live with?" I would be so devastated. Here I go again...looking for love...looking for that family...

At sixteen, everything came to an end: my abusive relationship with my aunt and my immigration

status in the U.S. I was sent away to a boarding school in Canada and soon ended up living with other foster families until I turned eighteen. At eighteen, I thought I was on top of the world. I thought that I had emotionally dealt with the pain of the rejection from my family, my aunt and all the other families. But soon my world would change again.

At nineteen, my boyfriend of four years broke up with me in a letter. I was devastated. Alone again. He had shared all my trials with my aunt, the immigration status and moving around with the other families. He knew my secrets, my pain – he knew my story. I had lost the one person that lifted me up and loved me in my darkest times.

Devastated, I no longer wanted to live. I inflicted pain upon myself, wanting to erase what everyone had done to me. Fortunately, my fear of becoming a statistic quickly pulled my senses together. Instead of killing myself, I asked myself one life-changing question, "What is it going to take to get rid of all my baggage?" I knew the answer was in Hong Kong. I borrowed $1500.00 and got an airline ticket to Hong Kong.

I looked up one of the families that I had stayed with when I was little girl and went to stay with them again. During the following months, I would have lunches with my Dad, my grandmother and other relatives to find out as much as I could about my mother, and myself. After several months of pestering my father about seeing my mother, I finally got to see her face to face. Up until this point I had

an image of my mother as the giant Wicked Witch of the East, like in the Wizard of Oz. And yet, when I saw her again, all I saw was a frail little woman who was so, so, so sick mentally. Suddenly, all my childhood fears flooded out of me and all I could feel was sorry for her. I remained in Hong Kong for a little over a year and by the end of my stay, I came to a couple of very important realizations. First, everything that I remembered was true and second, *I Did nothing wrong! For goodness sake, I was a child . . . an innocent child.*

Enlightened and relieved that I was able to find closure, I returned to Canada and after several years I found my husband and soul mate. The first year we were together, he took me to a Lou Tice seminar for my birthday. This was a turning point for my life because at this seminar I realized that I had been unconsciously healing myself all those years as a child through a very simple method.

Looking at the whole picture, I really had lost a lot in my life. I had physically and emotionally lost my family, my aunt, my boyfriend and even myself. It was all so painful and traumatic yet today I am so normal. So how did I recover from so much loss and rejection?

I remember when I first came to the United States. I was nine years old and I couldn't understand why I couldn't be with my mother and father. I couldn't understand why this aunt who told me I was part of her family would send me away to strangers. I couldn't understand why no one would love me. The only way I could deal with the pain in

my heart and the confusion in my head was to pull over the first adult in sight, who was usually a teacher at the school, and bleed all over them. I would cry and tell them my whole life story. After spilling my story, I would feel better. The adult usually felt sorry for me, gave me words of comfort and then I would carry on the day with this huge grin on my face.

One day an adult told me that I cried way too much and that my story sounded too unbelievable and that I needed to be more careful whom I told it to. As a result of that comment, I developed what I called a "poor me" session. My rule was I would allow myself to only pour my guts out for a certain period of time to someone I trusted. After the allocated time period was over, I had to smile, go on with my day and start appreciating all of the things around me. As time went on, the "poor me" sessions went from one hour per day to one hour per week and eventually to a few times per year.

This was my very simple method of processing: just find someone I trusted and talk it out with him or her. I know that as an adult, this simple method of processing somehow gets a little harder. However, even today I still feel better when I cry and talk it out with someone I trust.

As I'm writing my story now, I realize that telling my story over and over again since I was nine years old has actually been my savior and protector. Who knows? I might not be alive today physically or emotionally if I hadn't had someone to talk to. Talking out my problems gave me room for focus-

ing on the positive things in my life. I really did learn to appreciate the things that I have. Little things like food on the table or a beautiful cool breeze, or the people who came into my life and touched my heart. In the end, all the good that I focused on filled that big hole in my heart. Most of all, I am deeply grateful for my children and husband and the loving relationships that we have together. Yes, the chain is broken.

My story is about being rejected and constantly searching for love. After many years, I came to the realization that no matter how much I wish, I can't control others. I *can* control the amount of time and effort that I spend on loving and healing myself. The only thing I have control over is myself.

Here is a poem I wrote about my search for self-love:

The Mighty Oak Within

When there's more storms than you can bear,
And you're finding it really hard to care,
Remember that you are a mighty oak tree,
And that vision alone will take you there.

Forget about where you've been,
Work on finding that pillar within.
What does all this really mean?
It's to find self-love and self-esteem.

When you're questioning the purpose of life,
And all you can see is strife,
Know it's there with a goal,
Of filling in your empty soul.

Inside every acorn there lies a mighty oak tree,
Learn this well and it shall set you free,
Believe me when I tell you all this is true,
Cause I've already walked in your shoe.

After living with over 20 different families by the time she was 18, **Renee Dignard-Fung** overcame tremendous odds during her youth to build a successful family and career life. Her experiences enlightened her to share her knowledge with teens and young adults. Through her company www.teenmentor.com she teaches youth how to become more confident and productive despite all of life's obstacles. Today, Renee lives in Costa Rica with her husband and two small children ages 5 and 3…She is grateful that she was given the positive thinking and life skills to overcome her childhood challenges.

Beyond Fear

Gladys Varga

I can be lion, king of the jungle, roaring with my power, or a wicked witch, cackling with evil intent, a galloping cowgirl, a dancing skeleton, a queen of regal bearing, or a freedom bird. I can sail you through swashbucklers' adventures, march you into King Arthur's legendary battles, or send shivers down your spine as I walk you through a graveyard on a dark and stormy night. How? With words. Words are my world because I'm a storyteller. Not a liar, like some people might call a storyteller, but a true storyteller—a keeper of stories old and new, a protector of words and tales that have been handed down to us for generations. I bring characters and images to life. Storytelling is my passion, an integral part of myself that helps to define who I am.

This passion of mine makes perfect sense. In school, I always had "talking" marked on my report cards. My father used to ask, "Don't you ever shut up?" Today he must be looking down from heaven, saying, "I can't *believe* they're paying her to talk!"

There's always a story behind the story. The truth in my story came creeping into my consciousness while I slept, until an epiphany burst upon me like a window blind being raised much too quickly. It was a bright, sunny Labor Day in 1988 at the end of my college reunion. My husband, Richard, and I had a great time. Well, at least, I had a great time. Richard hadn't. It was the comments of those old college friends some of whom I had not seen for 12 years that awoke a tiny part of me that knew something was wrong. The one comment I remembered the most was my best friend's parting words. We had said our good-byes, and I was all the way across the parking lot. Suddenly, she shouted to me, "Just remember. There's nothing wrong with you. *You're* fine."

I'm pretty sure that Richard disagreed. He could hardly help but notice how I sobbed as we drove the 250 miles home. He thought I was crying because the reunion was over; but it was something much worse than that for both of us. I was crying because I knew my marriage was in trouble.

Once at home, I confronted Richard. With my heart pounding and my body shaking, I spoke the truth of things that I had denied for much too long: the snide comments that ate at my self-esteem, his

thinly veiled fixation with sex, the cloud of depression and negativity that hung over our family. The next few months were incredibly horrible and hard as we bantered back and forth about our problems. I'll never forget the turning point.

"I'm fine," Richard finally said with disgust one day. "I don't have any problems. I don't want to change. I'm too old to change. Besides, *you're* the one that's off the wall. *You* go see a therapist."

So I did. With the patient encouragement of a therapist to be totally honest with myself, I admitted that Richard had been emotionally, psychologically, and sexually abusing me. I realized he had no respect for me, no trust in me. Instead he held a twisted, addictive love for me. I was his obsession, and he wanted complete control over me.

And I had been his willing victim.

I was stunned, hurt, and angry. The man I thought I knew and loved suddenly looked like the Big Bad Wolf to me, a predator devouring my spirit. I felt tainted from his abuse and betrayed in my marriage. The love, honor, and devotion I had given Richard seemed grossly misplaced now. Worst of all, I felt like a shell of a person with no idea who I truly was.

One morning, two months after that fateful Labor Day, I sat on the side of the bed, sobbing as I stared into my open dresser drawer, so depressed I couldn't decide what clothes to wear; so depressed I thought that suicide was the only way out. In the midst of that excruciating pain, a tiny voice in the

Beyond Fear

back of my head asked, "Why are you letting a man do this to you?"

That was the day I began to climb back.

The months that followed brought a separation from Richard, a succession of part-time jobs, a lengthy list of horrific caretakers for my children, and more confusion on what I should do about my marriage. In therapy, I finally admitted that I had been molested as a child. I unblocked a date rape from college and completely faced the awful details of my abusive marriage.

It was like peeling away the layers of an onion. As I reached the core and delved into the exploration of my family of origin, I was startled and frightened. I unearthed generations of abuse, generations of female victims and male abusers. With sudden clarity, I realized that my 7-year-old daughter and my 4-year-old son were stepping right in line as victim and abuser.

Suddenly, a light bulb went off and that voice in my head said, "I've got to get out of this marriage!" I knew I wanted three things. I wanted to find out, once and for all, why all of my relationships with men had become increasingly destructive. I wanted to be a better person—emotionally and psychologically healthier. Finally, and most importantly, I wanted to leave a different legacy for my children than had been left for me.

It was easier said than done. Therapy plunged me into recesses of my emotions that I never realized existed. I counseled and read and wrote in my

journal, but each day was an emotional roller coaster and a battle as I struggled to work, care for my children, and cope with Richard's ever increasing anger over my new assertive decisions. He threatened to move back into the house, so I changed the locks. His lawyer filed continuance after continuance in the divorce proceedings. He lied to the children, telling them I was having an affair. There seemed to be no end to the roadblocks he threw in my way in his desperation to hold onto me. Fear and exhaustion seemed to grip me at every moment.

I finally saw one tiny ray of hope in the darkness that seemed to shroud my life. I had a chance to interview for a children's librarian position. If I could get that job, I could quit my three part-time jobs. I would have benefits and a reasonable work schedule. Unfortunately, the timing of the interview was horrible. The appointment fell immediately following an hour of intensive therapy delving into my abusive past. The interview itself was just as bad as the timing. My lack of confidence showed through like a blaring beacon from a lighthouse on a clear, cold night. My mind went blank as they asked me questions that should have been simple for a Library Science and English Lit major. I stumbled over my words as the fear of failure formed like a tight ball in my chest. I was *awful*. I left the interview more depressed than ever.

As I was driving home in the piece of junk I called a car, I blew a tire. Cars were whizzing past me, and no one stopped to help me. I was feeling the

weight of the world on my shoulders. I finally got the tire changed, ruining the only good pair of nylons I had in the process.

With an already splitting headache, I arrived home. It was like stepping into another world. The house was a wreck. My children were running around like wild beasts, while the baby sitter watched television, oblivious to the chaos. "How much sugar have these kids had?" I muttered to myself. No sooner did I rush the sitter out the door than the phone began to ring. On the other end of the line, my elderly mother told me she was being admitted into the hospital because of pneumonia. Now I'm thinking, "This day can't get any worse." I shuffled through the mail to see if my child support check was there; and instead, there was another letter from my husband's attorney, saying something about Richard having been a "good and faithful husband" and that he was contesting the divorce! My mind immediately began totaling up attorney fees. When the kids refused to eat the dinner I fixed, I almost lost it. "Just get them into bed and get some sleep," I told myself as I counted to 100. In true form, my hyperactive son fought me every inch of the bedtime routine. With the finish line of having the children settled in bed within my view, suddenly my beautiful, usually cooperative, daughter decided she had to tell me how sad her father was. Oh, she worked herself into a good tantrum.

"Daddy's all alone and unhappy and it's all your fault," she accused me, with venom in her voice.

And then she looked me right in the eye—I'll never forget it—and screamed, "I hate you…I hate you…I hate you…I hate you…"

For a moment, the world seemed to stop. Her words felt like a knife plunged into my heart. "I can't do this anymore," my mind screamed; and the fear began to rise in my throat again. Fear of no money. Fear of raising my son and daughter alone. Fear of doing a terrible job at it. Fear of my estranged husband and his temper. Fear of a seemingly endless series of days just like this one. But somewhere in that raging madness, the inner voice began to whisper the title of a book* that sat under my journal on my nightstand, *Feel The Fear and Do It Anyway*. "Feel the fear and do it anyway," that voice in my head whispered.

Those words repeated themselves in my brain often each day, until the phrase became my mantra. As the days passed, I began to trust that inner voice and let it guide me to a new woman. Then something happened that gave that voice and that new woman the true power they needed: I got the job as a children's librarian! My perception of the interview had apparently been skewed—I scored the highest of all the job applicants!

As part of my new job, I was sent to a storytelling festival. At that festival, storytelling struck me like an arrow to my heart and ignited a passion in me. At the age of 37, I finally knew what I wanted to do when I grew up.

The art form of storytelling was a perfect combination of my love of language, imagery, literature, research, and my ability to be at ease in front of others. Storytelling was something I could do, and no one could take it away from me. No matter how afraid I was or how low I felt, storytelling always lifted me up, always empowered me. I began to feel a pride that I had rarely experienced before, both for myself and this newly discovered talent of mine.

As I reveled in my personal and professional growth, Richard continued to fight me tooth and nail on the divorce. The children continued to blame me for the split family, as I struggled to keep a roof over our heads and food on the table. But ever so gradually, the seemingly never-ending road of mere survival began to shift and change. The roller coaster hills began to shrink. The path curved this way and that from time to time, but it definitely leveled out. Within two years of that first realization on Labor Day in 1988, my divorce was finally granted. The therapy for my children and myself began to take hold. And after a couple of years, big changes happened that never would have been possible before: I moved from Ohio to Florida, marrying a man who accepted every aspect of all three of us with open arms—ironically, my college sweetheart. Today, I'm a successful professional storyteller and the owner of Gladtales Productions. I present storytelling programs at schools, festivals, libraries, recreation centers, and a multitude of venues—creating just the right storytelling presentation for each client—all

with the guidance of that powerful inner voice. Our young adult children are thriving, and I am blessed with family and friends that make my heart swell with pride. But most importantly, after years of letting everyone else run my life, I have finally found the courage to be the master of my own life.

*Jeffers, Susan. *Feel the Fear and Do It Anyway.* New York: Fawcett, 1998.

Owner of her own storytelling business Gladtales
Productions, storyteller **Gladys Varga** has been
performing and presenting storytelling perform-
ances and workshops to audiences of all ages for
over fourteen years. Gladys believes in the power
of storytelling as both an academic and personal
development tool and became involved in
Powerstories Theater in the hopes of impacting
others through storytelling. The mother of two
adult children, Gladys and her husband, Steve,
reside in Englewood, Florida.

Surrendering to Life's Purpose

The Process Is the Destination

Karen Seitzinger

Music has always been an important part of my life. There were tap-dancing lessons at four, classical piano lessons for fifteen years beginning at age eight, the tenor saxophone in fourth grade and by age thirteen, I was playing the pipe organ. In high school, I was a majorette. Marching to the pulsating rhythm of the drums struck a chord that resonated to my very soul and I caught myself wishing I could take percussion lessons. I was already involved in every kind of music available; jazz band, marching band, orchestra, vocal music, accompanying for the Community Chorus...*and* the organist in our church. I could just imagine the look on my parents' faces if I suddenly came home and announced I

wanted to add playing drums to that list! Besides, there was this irrational authoritative voice in my head that kept telling me that girls aren't supposed to play drums. I was able to dismiss the idea of taking percussion lessons, but that didn't mean I had to give up my dream of being a music professor in a University some day.

I had led a somewhat sheltered life growing up in a small town in Iowa with my mother, Jeannette, a stay-at-home mom, my father Ed, who owned his own construction company, and my younger sister, Sybil. Small town life wasn't always sweetness and light. By age eighteen, I was already married and had two children. I had been one of those rebellious teenagers, crawling out my bedroom window at night for clandestine meetings with Jon, the love of my life and the bane of my parents. They said he was too old for me (he was a junior and I was a freshman), but what they really meant was that he was from the "wrong" family. The decision to go against my parents' wishes dramatically impacted my life. I was the only graduating high school senior who was married and pregnant with her second child.

Two years later, my parents gave me the opportunity to go to college. I could only attend part time due to my family responsibilities. This eliminated the possibility of a degree in music because music majors were required to attend full time. I had always been good at math and algebra, so I tried accounting and found I had an aptitude for it.

Over the next seven years, as I gained an education, my eyes opened to a world of new possibilities. Freedom was the central theme and I gradually became aware of the imprisoning relationship I was in. At the end of those seven years, I had a college diploma in one hand, and a divorce decree in the other. Obviously, accounting wasn't the career of my dreams, but it would provide a way to raise two children by myself.

Twelve years later, that college diploma along with some fierce determination brought me to the level of Controller for the Condo Management Division of the development company I was working for. But the cost to my personal life was extreme. I only knew one mantra work—work—work—work. In order to complete the corporate budget, I worked twenty-seven days without a break. I thought I had to; that anyone would sacrifice one's life for the corporation. It never occurred to me that their demands were unreasonable, I thought I just wasn't organized enough. When I realized that my work had permeated all aspects of my life from dreams to taking a shower, I knew that I needed to make some drastic changes, immediately!

The desire to bring peace and harmony into my life was answered when I noticed my friend, Trudy, exhibiting those very qualities. Her secret was Tai Chi. As she demonstrated the graceful, slow movements for me, I could sense the peace she feltThis meditation in movement intrigued me, and I

enrolled in the next session. The sense of well being I experienced during class time began spilling over into my everyday life. I found I could hold onto myself, even in the midst of all the corporate chaos. Drumming entered my life soon after. Inspiration appeared in the form of jam sessions held by a friend of mine. He lived in a graceful old Florida home, framed by gigantic live oak trees, nestled along the Hillsborough River. The house had one of those enormous wrap-around porches where all the talented musicians would gather to play. Me? I was on the sidelines, yearning with all my heart to get my hands on some skins. But I was immobilized by the voice whispering disparagingly in my ear that "girls don't play drums." During one of these jam sessions, I heard about a drum-making workshop being held in the area. I decided that this was exactly what I needed. I could make a drum of my own and *that* would give me the incentive to learn to play it.

I chose to make an African Ashiko drum at the workshop, which was held outside. All day long, a red-shouldered hawk was perched on the fence nearby, as if to lend its energy to the process. The cedar base was made from surplus lumber and the deerskin came from animals that had been hit on the highways. Whenever I play it, I am reminded of the sacred agreement of the cedar and the deer in coming together to form this beautiful instrument. The voice and vibration it carries are very sacred to me

and through it I can access the deepest parts of my soul.

My life felt quite full after bringing these new aspects into it. Gradually, however, I became aware of an underlying feeling of discontent. I longed to do something different with my life that would make a positive difference in the world.

One day as I was returning to work after lunch, I started telling my friend Sharon about my mom. She had been reading about a very famous medical intuitive named Edgar Cayce, when I was in junior high school. All he needed was a person's name and physical location in order to connect with them from a trance state and diagnose their illness. This led me to recall the energy healing session I had received recently from my friend Lora Lynn. She was attending a school to learn about hands-on healing and needed someone to practice on. The world of alternative medicine had piqued my interest.

In September, Lora Lynn invited me and Tom, my life partner and my Spirit Dancer, to come to her house in Virginia for a Sweat Lodge Ceremony. It took fifteen of us all morning and into the afternoon to cut down the saplings for the frame, to fill one hundred prayer ties with tobacco, dig the fire pit and assemble the teepee in the woods next to her house. During the ceremony, we all sat in a circle inside the lodge. The fire pit was filled with red-hot rocks that popped when the Shaman sprinkled sacred sage over them and hissed when he poured water over them. The purifying steam enveloped us all as we

sat in the lodge and began the sweat. We sat for hours. The heat from the steam and the rocks became so intense there was nothing to do but surrender to it over and over and over. Afterward, in the silence of that sweet surrender, I sat on Lora Lynn's small, nondescript porch overlooking a tobacco field with the mysterious blue haze of the Appalachian Mountains in the distance. Writing in my journal, with my feet tucked under me, I suddenly knew to the very core of my being that I was destined to study hands-on-healing at the Barbara Brennan School of Healing in New York.

That night, as we were preparing dinner, I revealed my important decision to go to the school this fall. Several of my companions were already students at the school and said I would have to attend a weekend workshop first. Since I was so determined to go this year, one person recommended that I talk to Laurie Keene. They all warned me to avoid Maureen Morganthe ex-Marine, at all costs. When I called the school the next morning, the receptionist informed me that Laurie Keene was out of town, but she would connect me with Maureen Morgan. I caught my breath and found my heart beating wildly. Visions of boot camp passed before my eyes. The first thing she wanted to know was which workshop I had attended. I decided I'd better do some fast-talking to deluge her with all the reasons why I was fit to go to the school immediately. I began by explaining my desire to attend the school; I'd heard that foreign students didn't have to

meet the workshop requirement and was wondering if I might also be exempt because I had a sense of how energy worked since I had studied Tai Chi for a number of years, had already experienced an energy healing session from one of the students there, and most importantly that I had received very strong guidance after attending a Sweat Lodge ceremony that I was supposed to go to the school this year. Whew…all that was said in one breath. I figured if I didn't let her get a word in edgewise I might have a chance of winning her over to my side.

I was conscious of holding my breath as I waited for her response. She totally surprised me by saying she would be willing to take my case to a committee for review and could get back to me within a couple of days. Tom and I were planning to stay in Virginia for the next week anyway, so I figured this was a good sign.

Two days later, Maureen called back. I was so positive the answer was yes, that I had to sit down in order to absorb the words that were coming through the phone. "I'm very sorry, but the committee has decided to uphold its admittance policy. There is a reason for the weekend workshop. It gives the prospective student an opportunity to experience some of the work and a chance to decide if they want to pursue it further. It also gives teachers at the school the opportunity to evaluate the prospective student to be sure the person will be able to handle the intensity of the training over the next four years."

I could feel myself sinking further and further into the chair as she explained all this to me. I suddenly found myself very calmly offering to travel all the way to New York City for a personal interview, so she could see for herself how sincere I was. She said she was very sorry, but there was nothing she could do. She gently suggested I look around for the next weekend intensive to attend, so I might apply to the school the following year. I hung up the phone in a state of confusion and disbelief. I had felt so strongly that my guidance was pointing me in this direction.

Tom and I went hiking on the Blue Ridge Parkway the next day. Being in nature, in the still quiet spaces between trees and mountains always helps me connect to the sacredness within myself. The physical demands on my body while climbing over rocks in the middle of the rushing stream took tremendous focus. As we made our way back to the trail, I saw a yellow butterfly floating softly over my shoulder. It was so delicate and yet so strong, full of purpose and yet yielding to the breeze. I realized I needed to let go of my expectations of attending BBSH this year and allow God's divine plan to unfold, instead of willing it to appear. Thoughts of finding a weekend intensive in an interesting location begin to intrigue me. After all, it must be for my highest good to wait a year, I told myself.

When we returned to Lora Lynn's house, I had a message waiting for me from Maureen Morgan. She was coming down to Arlington, Virginia this

weekend to visit her son and wondered if I would be willing to meet her there for a personal interview? I could hardly believe my ears! How could this possibly be happening, just when I had gotten used to the idea of waiting for a year? She mentioned that this meeting didn't assure me of gaining entrance to the school, it was just an interview. Well, "just an interview" or not, I was excited and scared all at once. I had so many butterflies in my stomach I felt like I could float away at a moment's notice.

Tom dropped me off at the entrance to the hotel across the street from her son's apartment at the appointed time. Several minutes went by before an auburn-haired woman, dressed in black pants and jacket walked in. Our eyes met and I knew it was Maureen. I rose to meet her as she smiled at me and extended her hand.

We sat down next to each other on an over-stuffed couch and she asked me why I wanted to attend the Barbara Brennan School. The words just started spilling out of my mouth. I told her about reading Edgar Cayce's books, my desire to leave accounting and enter a profession that gave positive things back to humanity, the years I had studied Tai Chi, and most importantly the strong guidance I had received.

Toward the end of the interview, she said she would like to see how I ran my energy and that she was going to lead me through an exercise to access that energy in all of my chakras. As we went through each one, she described where it was located and

how to spin it in a clockwise direction. We went from one through seven. I was very nervous, knowing this was the final test. Afterwards she looked at me and said, "The Barbara Brennan School would be happy to have you as a student this year."

Relief flooded my body as tears streamed down my cheeks. We gave each other a big hug, and I wondered what all the fuss was about. This woman had a very big heart and I was extremely grateful for her willingness to meet with me. I also realized my guidance had been right after all, it was the surrender part I had to experience first.

The next four years of training changed my life in very profound ways as I began opening up to my gifts. I gave myself permission to play the piano without music in front of me. I could now access the creative energy from within and allow it to flow through my heart and hands onto the keyboard. I started writing my own music. Eight other women and myself created a percussion group called Raisa and we began performing together. During my junior year at Barbara Brennan's School, I opened a private healing practice. I quit my job in accounting and vowed never to return. For seven years, I worked very hard to create a full time practice that would support me financially. I had many conversations with God about what I was supposed to do with my life during this time. I opened and surrendered, wheedled and cajoled, promised and threatened. And still my practice couldn't support me.

Healing was my passion, my life's purpose. Why wasn't it working for me?

My bleak financial condition forced me to give up my practice and go back into accounting. I felt on a soul level that I had failed to create my life's purpose. I was convinced I had done something wrong, and if I could just fix whatever it was, I could have the life of my dreams.

Over the next few months I set my intention to reconnect with my soul's rhythm. I spent a lot of time playing my drum and the piano, writing in my journal, meditating and doing energy-healings on myself. Eventually, I was able to see that I had expected my healing practice to be the end result of my life's purpose. But my life's purpose is not what I do; it's whom I am inside. I finally came to understand that all life is valuable. Every act is a choice to be in alignment with my purpose, to access and share that inner spark of Divine Light that resides within me no matter whether I am in the corporate environment, in the grocery store, writing music, or in the healing room. For you see, I have learned that the process is the destination. Namasté.

Karen J. Seitzinger leads a creative life that includes a private practice in energy healing, playing and composing music, practicing Tai Chi, writing short stories and performing with Powerstories Theatre. Karen owes her creative talents to her mother and therefore dedicates this story to Jeannette Putnam Seitzinger, whose angelic presence continues to have a profound influence on her life. Namasté.

Awaken the Spirit Within

Deanna Wefel

Over ten years ago, I had the most vivid dream. I dreamed that I was standing in an open pavilion with Grecian columns and a canopy of white clouds in the blue sky above my head. In front of me was a beautiful woman wearing a long, white gown, like a wedding dress. She did not speak a word but asked, "Are you going?" I looked past her right shoulder and saw in the distance a small, white building without windows. In front of the building were more people dressed in white robes, standing in rows of three, all facing towards the woman in front of me. They were standing the way birds do, waiting to follow the leader. I refocused on the woman standing in front of me and said, "No." She looked at me as though she could look inside my soul and asked,

"Are you sure?" Suddenly, I was viewing her from two places. One was right in front of her and the other was as far away as the length of a football field. From the most distant view, I saw myself standing in front of her but then I saw my husband standing behind me. I refocused on her and said, "I need to stay here longer."

I call this my angel dream and it is very significant to me because I was healthy at the time but just three weeks later I found a lump in my breast and was diagnosed with breast cancer. I was totally devastated. I did not want to leave my life! How could this happen to me? After all, I was nestled in a comfortable world. We lived in a relaxing community with lakes and paths for walking. My husband, daughter, son and I would regularly spend an entire weekend at a theme park and life was fun because we could all enter this make-believe world. There were no police stations, no hospitals, no homeless people. We could avoid newspapers and the horrible things happening in the real world. We could walk the streets and not worry that someone would rob or mug us.

Overnight, my comfortable life shifted into a wild ride of terror. On the night I had the dream, I had seen my gynecologist for my annual exam and mammogram (and had passed!). When I found the lump three weeks later, the doctor said he was 97% certain that it was not cancerous. But he sent me to the hospital for another mammogram and a sonogram. It was a Friday and by the end of the day no

one was around to tell me what this lump was. It was a weekend cliffhanger. I called my doctor on Monday and he told me to see a surgeon the next day for a biopsy. A Spanish doctor did the biopsy, inserting a large needle in my right breast, all the while recounting a story about the swallows that return every year to San Juan Capistrano. I left feeling very small, like a hurt bird that kept landing in places looking for answers but not finding them.

After the biopsy, I went shopping and found a crystal clock for my husband who was away on a business trip in South Carolina. Life goes on doesn't it? Business trips, shopping, they never miss a beat. I returned to the surgeon's office at 3:00pm and sat in the corner, waiting for the results. While he was shuffling papers, I looked around his office and noticed his pictures and statues, all of large strong animals. Even the furniture looked strong. This man was really a dragon slayer. Finally, he peaked over his papers with his glasses down to the end of his nose and spoke in unintelligible medical terms. I asked, "Do I have cancer?" He replied, "Yes." Suddenly, the room was moving, swirling, rocking, and I was being swallowed up. I asked, "Am I going to die?" He never answered me. He said that this was going to be a roller coaster ride of emotions. He explained that I had a choice to make: have a mastectomy or a lumpectomy. He wanted to call my husband but I asked him not to: it was hard enough to deal with my own emotions. He told me to come back in three days and let him know my decision.

This was the worst day of my life. I cried all the way home in the rush-hour traffic. Don't these people know they are all going to die? Don't they realize life can change in an instant? It was just last week that I was like them, thinking of the little things that made up my life. But my life had changed. I was in a fight for my life. My thoughts were different now. Off with my breast and reconstruction? Or lumpectomy and radiation? When I got home I told my children. My daughter took it in and it was hard to tell what she was thinking. My son responded by crying and I cried with him.

It was all so much to decide in three days. I carried all the films, mammograms, sonograms, x-rays, and bone scans, to my gynecologist's office. I was lucky — it was lunchtime and my doctor gave me an unscheduled hour to see him. I laid out all of my films and we went over the particulars. Both procedures carried the same odds for survival, so I decided on a lumpectomy.

Within a few weeks, I had the surgery to remove the lump and the surgeon also took out the lymph nodes under my right arm. One lymph node had cancer cells in it, so the cancer had already started to spread. As I was recovering, the surgeon came in to my room and told me my treatment had to include chemotherapy. That wasn't part of the deal! Why chemotherapy? I can't do chemotherapy! Other people do chemotherapy, not me! Why does he think he can come in here and tell me this? It

wasn't part of the plan! Why? Didn't I have enough to think about already?

It was difficult to do the first treatment. I felt like a deer caught in headlights. But my husband said, "Think of chemo as your friend that's trying to help you." I did and it was.

Sometimes I wish I could have taken a class, like Breast Cancer 101, just to know how to do it right. Breast cancer, hmmmm, let me check my calendar…I've been to the hospital now so many times, they know me more by my breasts than they do my face!

Soon after my final chemo treatment, I had difficulty breathing. I called my doctor who told me to come to the office immediately, no stopping. The doctor did an EKG and listened to my heart and lungs. He told me I might have a blood clot in my lungs and that I needed to go across the street to the hospital and have a lung test. My lungs were filled with clots. I had to stay flat on my back for several days. At that point, my odds were 30% chance to live and 70% chance to die! I now wanted to rush back to the problems of "just" breast cancer.

I was lying on my back, terrified to move, when the angel from my dream came back. Her name was Raina and she asked me again if I was going and I told her, "No, I need to stay here longer."

Now with breast cancer *and* pulmonary embolism I really needed to beat the odds to live. I first had to develop a *sense of humor*. All my hair fell out from the chemo, so I had to wear a wig…but

I didn't expect my cat to lose her hair! It was bad enough finding a wig for me but finding one for kitty was too much. Every day I would wash my wig and set it on the counter to dry overnight. If it wasn't dry in the morning, no problem. I would just attach my wig to the ceiling paddle fan, turn the switch on "high" and in minutes, I had a full set of hair. Humor is the best medicine!

The second way I beat the odds was using the *power of thought*. When I was in the hospital flat on my back with pulmonary embolism, I fluffed up my blondest wig. I polished my nails in Shocking Pink. I applied my makeup as though I was up for the Academy Award for Best Surviving Patient. I was on the phone like a teenager – keeping my place out there in the world. It was my intent to live.

While in Intensive Care, I had to *visualize* being healthy again. I realized I needed a theme song to visualize, so I chose "Just Roll with It Baby," and I did. Then I decided I needed a mascot, so I chose the bumblebee because aerodynamically a bumblebee shouldn't be able to fly but it does. I was going to BEE a miracle too, just like the bumblebee... and live!

I left the hospital a week after my breathing scare and started the postponed radiation treatments a few weeks later. Six weeks of daily radiation. First came the tattoos on my right breast so I would be lined up perfectly for the radiation treatment each time. I felt like my right breast was lined up with the universe. In fact, it was my universe. Everything in

my life was about my right breast. The radiation treatments were exhausting. After six weeks of radiation, I felt that not only should I glow in the dark but I should also have an honorary PhD in Fatigue. I was tired. For two years I was tired.

One year after recovering from chemo and radiation, I noticed a fast-growing bump on my forehead. What is this? What is happening now? I went to the surgeon for a biopsy. The bump was a Sarcoid Granuloma. What is that? Another potentially fatal disease! Over the next three years I had my forehead opened by a plastic surgeon three times.

Three years after being diagnosed with cancer and still in the midst of surgeries for Sarcoid Granuloma, I found I needed to talk to someone and tell them what had happened to me, how my life had changed, and how it was turned upside down. It was *great* getting it all out. I told a therapist my story and it was like reliving it. After a year of weekly visits, I finally cried for myself for the first time.

Not long after my recovery, my brother became sick. I was six years old when Sidney was born and I could hardly wait to hold him in my arms. I loved him from the moment I set eyes on him and he had the most beautiful big blue eyes you ever saw. My little brother grew to be 6 feet 5 inches tall and he was as kind and good looking as he was tall. He always greeted people with a beautiful smile and made friends so easily. We kept pretty busy throughout our lives but I never took him for granted. Even as adults, when we moved several states apart, we always kept in touch. I dearly loved my brother.

Sidney's stomach had mysteriously swelled and he went into the hospital for tests. Cancer was everywhere. It was so extensive the surgeon couldn't even find the point of origin. I sat in my living room and cried. I was the first cancer patient in my family and my only brother was the second. I asked my angels and his to come together and to stop whatever was happening to him. I said it could not be time for him to go. I would not be able to let him go. I pleaded with his angels to help him. I prayed to God that He would help my brother.

Then I lost my job suddenly due to a company merger. Thank you, God, for giving me this precious window to go to my brother's side. When I arrived at the hospital there was a stream of friends and relatives to see Sidney. Most of us could not believe this was happening. It seemed so surreal. How could this happen to Sidney? He was always so full of life. But everyone was here to say their goodbyes to Sidney. There was hopelessness in many of the faces that walked into Sidney's hospital room. Sidney's three sons, Jason, Erik, and Brandon, were numb but knew their father always had solutions. They knew their father could fix anything.

Sidney lay there with a slow IV drip, lines in his arms, his abdomen swollen from the cancer and the total blockage in his stomach. Sidney's physical problems could not be solved by either surgery or drugs. The doctors said he would never eat again and he would die within a week.

The next morning a woman from Hospice arrived with forms for Sidney to fill out. Sidney and I looked at each other and declined her services. We decided on a different path, one that we would create. Sidney checked out of the hospital and returned home to live with his three boys, who were happy to have their father home. They really didn't understand what was happening. They saw that their father was home and they knew life would go back to the way it used to be.

If it wasn't for my own experience of dealing with cancer, I would have been lost about what to do for Sidney, but fortunately, that was not the case. I stood in front of Sidney, looked up, and said, "Sidney, we know what the doctors told you. We know they said you would never eat again and that you are reliant on these tubes and feeding lines. The cancer is everywhere. The cards are stacked against you, Sidney, but we are not without hope." With sadness in his voice, Sidney said, "I feel like all my dreams have been taken away." Inside, my heart cried. We all need dreams. Dreams are what propel us to manifest our lives. We had to get his dreams back!

"Sidney, we are going to take your records and bring them to an oncologist on Monday and have him read the doctors' notes."

The oncologist was surprised at our assertiveness. "Take your best guess, put your recipe of chemo drugs together, and let's get started," I said to

him. The next morning, Sidney sat in the infusion center getting his first hit of chemo.

I looked into Sidney's eyes and said, "You must change your thinking. Whatever the problem, you can't internalize it any longer. Your body cannot handle it." So many people who internalize their problems end up with stomach problems or they cannot eat or they have ulcers. All of Sidney's woes and worries went to his stomach. Sidney had spent years as a single father raising his children by himself. He was used to smiling to the world no matter what happened to him.

I told Sidney that he must use his mind to heal his body. He needed to connect to the higher power, too. Prayers are powerful. I told Sidney to envision the diagnosis that the doctors gave him and acknowledge it. Then, envision a bright light surrounding that diagnosis. As simple as it seems, it's a powerful vision in your mind, heart, and soul. "You can't get a miracle unless you expect one," I told Sidney. "You must envision yourself still being here and expect it." Sidney did just that.

The next few weeks Sidney held on with both fists. We worked to get rid of the tubes and feeding lines. Our mother brought over fresh peaches and Sidney took one, cut it up, and made it into a puree. He slowly tasted it and it was good! He began trying very bland foods and soon was able to eat once again. With the feeding tubes gone and regular chemo treatments, Sidney was getting better and better each day.

I knew Sidney would have liked me to stay forever with him and his boys but my husband and children were back in Florida. "Keep envisioning tomorrow and keep envisioning getting better!" I told him. Sidney stood in the middle of his yard, waving goodbye to me as I drove off.

Sidney lived each day fully and completely as he recommitted to life. He learned to be a warrior and to take charge of his circumstances. Sidney kept his vision and was here four and a half years longer than the doctors predicted. During that time, I visited my brother several times and we talked on the phone regularly. He would tell me about fishing trips, what he and the boys were doing together, his parent-teacher conferences, his constant canine companion, Harley, his doctor visits, his latest work project, the weather, the news, and how happy he was that we didn't accept the three days the doctors had given him to live!

On the evening of November 4, 2002, my brother's life here was ending. As he lay in his bed, the phone was held to his ear and I lovingly told my brother it was all right to go to the next place, the place that we all go to, the place where I will meet him when my work here is over. I told him I loved him and not to be afraid, as this was a passage we all must take at some point. I told him he was a great warrior who had led a great battle, that he was a great brother and that I loved him.

That night, my husband and I went to Clearwater Beach and stood next to the pier that

Sidney and I had once fished at until one in the morning. We looked up to the stars connecting with this awesome universe. We knew Sidney's journey was changing now and we stood in the sand along the water, held each other and prayed for Sidney. We prayed it would not be a painful transition and that God would continue to watch over him and would surround him with His love. We acknowledged we would miss him dearly and we thanked God for having helped him throughout his life, especially the past few years. We were thankful, too, that he had more time with his children, friends, and family, and more time to enjoy his journey here.

After my brother's death, thoughts of my angel dream would come back to me periodically, reminding me why I chose to stay here longer. Just as it happened with Sidney, the universe presented me with another opportunity to help someone close to me.

It was almost four years ago that my husband, Bob, was out riding his Harley motorcycle on a beautiful Sunday afternoon. He had gone to a fundraiser in St. Petersburg and while riding back to Tampa he began to feel sick. He stopped at a gas station, took two aspirins and, after a ten-minute rest, got back on his bike and proceeded toward home. Suddenly, he could not see the traffic light colors, broke out in a cold sweat, and felt a squeezing pressure around his back and chest. His body was shutting down and he was feeling very dizzy. He knew he could not stop. He put his bike in third gear, rest-

ed his head on the windshield, and kept driving towards the hospital across the river. He parked his bike in front of the Emergency Room, walked in and was immediately seen by the doctors.

When I arrived at the hospital with our son, a cardiologist brought me into a room that looked like the command center for a spaceship, buttons and screens everywhere. He showed me the results of tests they had done minutes earlier. The doctors said my husband needed a triple bypass. The only thing I could think of was, "How can Bob survive this?" It seemed like he was in a corner and he could not get out.

In his hospital bed, Bob told me he was not going to be cut up like a chicken. I thought, "He only has one chance and this is it!" Chicken or not, he would die without surgery. "You're going to have the surgery," I told him. But my mind spun! What could I say to him to change his mind? In a moment I knew. I grabbed our son's arm, pulled him closer to his dad and said, "Because this guy is going to get married one day and you are going to be there!"

Five days later, my husband, who was as afraid as a chicken, had a triple bypass. It was an all-day surgery and when the surgeon came out to tell me Bob was okay, I could not speak. I could only put my arms around him and give him a hug to thank him for saving my husband's life. Are there any words to express this kind of gratitude?

The next time I saw Bob, he was on a life-support machine. He could open his eyes but there were

tubes everywhere. His brother and I stood on either side of him. Bob could only move his little finger, but it was a movement of hope, a signal that one step had been taken, and we would all make it through.

Within days Bob was home and recovering. It was a long process because heart surgery is very invasive: his entire ribcage was sawed open and there was a lot of work to open up his arteries. After surgery, he needed assistance getting in and out of a chair. Just walking was difficult for him. It was frightening, but he was determined. Like me and my brother before him, he also became a warrior when his life was threatened. It's probably one of the most frightening things of all to come out on the other side and live. It takes courage. Bob still works on his recovery every day. He stays in the middle of life, keeping active in things he likes to do. He works towards having a healthy body and mind once again. In his heart, he knows today that angels do ride Harleys!

My angel still comes to me in my dreams. Once, I asked her why humans go through so much pain. "Taking those life lessons that are painful and then helping another go hand-in-hand. Using both fulfills universal, spiritual love not only to mankind but causes celebration within the spiritual universe. What everyone does in their life matters, especially if it is to help others. It is then that we connect more with the miracle we are part of and become awake and aware of our own spiritual connection to the universe."

The most painful events in our lives have the power to force us to choose between hiding in a shell and embracing life. I am glad I learned to embrace life. I have learned to live with joy and laughter in my heart, to embrace and use the power of thought and prayer, and to invoke my ability to envision and create positive change. Through my journey, I've learned that we come into this life as spiritual beings but we live in a body. It's like our spirits are checked in to this large, beautiful, hotel. We have one thing in common: we all have to leave at some point. But there are different times of departure for all of us and we never know when our time will come. So, live life with your eyes open and embrace your life journey.

Deanna Wefel was diagnosed with Breast Cancer in 1993. She was born in a small Native American town in South Dakota and presently works for the Seminole Tribe of Florida. She lives in Florida, is married and has two grown children. She has performed in Powerstories Theatre for the past three years telling her story of surviving Breast Cancer. She has contributed in making a documentary on cancer survivorship and television segments on surviving Breast Cancer, speaks to groups promoting Breast Cancer awareness, and created the 2004 Breast Cancer Awareness pin for the Seminole Hard Rock Hotel & Casino in Tampa.

Jumpin' For Joy

Joy Blythe

When I was born, I was baptized as Allyson Blythe
Marshall. The "Marshall" came from my dad's side
of the family. They were good people, who always
worked hard and did the right thing, who walked the
praiseworthy path. My middle name, "Blythe",
came from my mother's side, a family of artists and
fierce, courageous spirits: my grandfather died on
the island of Iwo Jima; my great-aunt Peggy, still
alive and energetic, is never without some creative
gift project in her hands. And the name "Allyson"?
It gradually took on its own meaning, as I grew up
and filled it with the person that I was becoming.

By the time I was thirteen, "Allyson Marshall"
was a shy, well-behaved girl. She was a good stu-
dent, often the teachers' favorite. She never dared to

step out of line or to make any noises to this day I still have trouble saying the word "fart" with any semblance of casualness. About the wildest I ever got was to put albums on the record player, like "Annie" or "The Wiz," and skate around in my socks singing. That is when I felt the most alive, the happiest. Yet, for the most part, I was very much a "Marshall" studious and organized, dutifully keeping myself in check.

Well, that got BORING. Here was this Allyson Marshall person being such a "good girl" and inside, just like her middle name, was this passionate Blythe spirit, which was desperate for something more than this dry, predictable life. And so that spirit busted right out of me, as it probably does for many young people right around the time of adolescence. And for about four years, I totally let go breaking many of the rules that nice little Southern girls are expected to follow. Rules like: "Don't drink," "Don't smoke cigarettes it's not ladylike," and, Lord have mercy upon us, "DON'T have…well, you know… *sex.*" This holds not just until you get married, but *ever*, I think.

At that time, the more I could spit in the face of propriety, the better I felt. I not only skipped Sunday school to smoke cigarettes in the church bathroom and flaunted my bare white bottom during sex in my friend's front yard, I also drank as much, and as often, as I possibly could, even if it meant defying school and state laws to do so. I drove in blackouts, drank until passing out (sometimes in my own

urine), and I defined a "great" day as one on which I could successfully purchase a twelve-pack with my fake ID and not get caught missing class while consuming it.

Yet few pubescent rebellions are long self-sustaining, and this one got out of control and became painful quickly. A typical night ended not in the fun company of friends, but instead alone in my car, parked hidden atop a parking deck, literally crying into my beer. (The fact that it was usually a warm Milwaukee's Best makes this picture all the more tragic.)

I felt ugly inside and hopelessly rejectable, like a doll made with a manufacturer's defect, and my shame pushed me deep into isolation from others and into a profound desperation for escape. Not even my "best" friend knew what I really felt and thought how could I possibly reveal how disgusting I truly was? Yet alcohol? Now *there* was the ideal friend: reliable, non-judgmental and, most importantly of all, divinely numbing. It was nothing less than an intense *spiritual* longing, a grasping forth for peace that propelled me into daily drinking. But unfortunately, though it sedated me loyally and gently into oblivion, this "heaven" only lasted as long as the drunk did, and when it was over, so was the peace. Add to that another night's worth of embarrassing phone calls and lost underwear, and it was not long before I admitted complete defeat.

So I decided I had to shape up. And I did. On one particularly lonely and self-pitying night, at age

nineteen, I heaved the remains of a hot twelve-pack of Busch beer into the dumpster at the 7-11 and drove home in a shock, knowing that my life was forever changed. I committed wholeheartedly to a recovery program, quit using drugs of any kind and even stopped smoking cigarettes within the year. I felt amazingly liberated from my "compulsion" to drink, and yet though I knew it not at the time this freedom cost me.

Remember that intense spiritual longing? Passion like that does not just go away. It is either squelched temporarily or it promptly transfers to some other department. In my case, a mere squelching would have been ineffectual I had to strap it down with barbed wire. As I said, life had definitely brightened, at least on the surface, but now "The Rules" were back to govern me. And this time they got worse. I monitored literally every penny that I spent and every single crumb that I ingested. My daily exercise regimen was non-negotiable and did not include enjoyment, nor days off. The self-imposed limits on what I could buy at the grocery store were surely reasonable (that is, if you were in a *coma*) only cruelty-free, dairy-free, fat-free, preservative-free and environmentally-sound products were acceptable. I was not allowed to watch TV during the day or sleep in, and I was required to meditate twice a day, even though I hated doing it. I call this anal, militaristic party-pooper inside me my "Hitler," and he likes to make sure there is no fun

going on. Fun makes him crazy. He had me enslaved.

Once again, things had to change. My life was monotonous and obsessive, and there was this little person inside of me, screaming — for ice cream and naps and movies, and I knew she was going to start raging if I did not attend to her pretty soon. It was that same Blythe spirit in me! It had made its way back up to my surface, despite how I'd tried to bury it. To acknowledge her demands felt far too indulgent, even dangerous, yet to ignore the little hellion was a strategy that clearly would only work for so long.

As things often happen, I was led into my solution without even realizing it. See, the Universe never gives up on one of its creations, even if that creation is hopelessly self-obsessed, and it never leaves you wandering in search of joy without taking you there. You just have to have your eyes open for it. So, one morning I was having breakfast with a friend and, as usual, obsessing on how I would love to order, just *once*, a stack of those steaming blueberry pancakes that kept walking by, and how I would smother them with butter and maple syrup and lay one orgasmic forkful at a time upon my eager tongue, while my eyes would roll back in ecstasy at such delectable sweetness and... Meanwhile, I was only vaguely aware of my friend's droning voice, until she said something about this girl named "Bliss" and the name snapped me out of my reverie "Bliss" what a cool name! Why weren't

my parents cool enough to call me something like that? How did I get stuck with the dufus name "Allyson?" And then, in a moment of cosmic brilliance, surely underscored at the same instant in Heaven by a spontaneous Hallelujah chorus, the golden idea scrawled itself across my weary brain: *I can change my name.* Of course I can! It was like being asked if I could tie my own shoes. "Duh! I'm an *Aries* - I can forge my own path. I can do anything I want! I can choose my own name!" So I did. I changed it. To "Joy."

The name picked me, really. Within half an hour of my epiphany, it had filled me up so full that I nearly had to pee. In my excitement for my new identity, and all through me, I could feel it and hear it and taste it: JOY. I suddenly had so much to look forward to! Oh, and I figured that as long as I was stripping, I might as well take it all off, so I got rid of the "Marshall" half of my name, too, and left "Blythe" as my last name. Joy Blythe. Now, finally, I felt I was using my true name.

Some Native American tribes have a tradition of giving their children a temporary name at birth, until they are old enough to choose their own name, the one that corresponds with who they are. I cannot say I had practiced an awful lot of joy up to that point, but remember that sacred whispered pronouncement, "If you build it, they will come?" Well, I built it, created a space for it. And I'm here to tell you: it *came*. From deep within, it welled up in me, like the ocean current that strengthens before a

storm, and then pushes itself out in strong, curling waves. I rode on those waves, like a surfer finding her balance for the first exhilarating time. I did not have to spend myself on treading water anymore. No! Now I was way up high, and I could finally feel the sun healing me with its warmth and notice the sharp blue sky and the faces of my fellow swimmers. Hey! Maybe now I could even teach some of them to surf (ah, what a novel concept to get out of myself).

I was living in Colorado at the time, and I could not have found a more fitting backdrop for my spiritual revolution. I found a Sunday group that met by a river in the summertime. I could actually go there — to church — barefoot! You're not supposed to be able to do that! You're supposed to wear panty hose and a dress and keep your face all "religious" — looking (i.e., guilty). I sang in the choir, and though we were hardly a melodic bunch, you would not have known it to look at us. We giggled at our harmonies; we were shamelessly sappy; we altogether forgot what guilt meant, at least for that hour. My feet were so happy in that cool grass, and I literally sang my heart out. When I would go hiking in the nearby mountains, I would often see these incredible birds, just soaring along with their mighty wings, and I felt like I could just lift up my own wings and fly right off with them. Amazing people began to walk into my life and to act unknowingly as teachers, almost as if some unseen force had mag-

netized us together. JOY had ascended into my life. Why? Well, I invited her.

When I am out in life, stressing out about something "important," I have made a choice. The beautiful thing about life is that we can choose again at any moment. Being a revolutionary, I like to make the radical choice, and, if I can muster up even the tiniest willingness, I dare to *laugh* at the situation instead. And guess what. My laughter changes me. The power of laughter is startling.

I saw the greatest bumper sticker one day. Of course, I spotted it at precisely the moment when I was feeling overwhelmed by all my "problems" (you know, things like losing that vitally important earring and will I make it to the store for chickpeas before it closes?). And there it was — the single most profound supposition on life's true meaning that had ever been stated, uttered humbly from the rusting bumper of a Dodge Dart: "WHAT IF THE HOKIE POKIE *IS* WHAT IT'S ALL ABOUT?" Whoa!! I think it might be! Needless to say, my "crisis" instantly evaporated, and I embraced my inner goofball and drove all the way home crooning seventies love songs as loudly as I could muster. Yes, laughter is powerful, *miraculously* so.

This Universe, in which we tickle ourselves if we so desire, is rich and juicy, and it wants to saturate every vessel with its sweet nectar. It is just looking for open containers. Are we open? What does it mean to be "open" anyway? I go to these Quaker meetings, and I only so much as look at the people

there and I am convinced of the goodness of the Universe. These people are vessels, walking clay pots, constantly being filled up and radiating with light. And you know why? Because *they welcome it. LET THE SUN SHINE IN!* They know it has always been there, eager to light us all up like fireflies. They are also wise enough to give it away, keep that electric wealth flowing. They know what they cosmic deal is. And I think I am finally beginning to absorb it now too: *I Let* Go...and the Universe fills me, with this deliciously peaceful sensation, like some spiritual serum (Love Potion No. 10?). Now, I am *not* going to count the calories in that one, thank you. It means having to release my clawing death grip on some old ways of thinking, but that is a bargain considering how I used to live — full of fear, thinking it was all up to *me* to keep my life in control and bearable. Thank God that is not the case! Managing my own life was a terrifying and impossible business, the worst job I ever had. What a relief it is to discover that this is not my true job assignment after all! As it turns out, it is actually *in my best interest* to drop the whole attempt and take a vacation to some cosmic tropics, a vacation which I now intend to make permanent.

Now, believe me, Fear is still one of my very closest friends. Fear that I am not pretty enough, that I do not work hard enough, that I am not as good at things as other people are. But even when I am in all that sludge, I still have this *connection*, to this voice inside of me. Imagine the voice of a little guru-man.

For me, he sounds like a cross between Jerry Garcia and Billy Crystal doing that old Jewish grandfather bit. It is always there if I listen for it — guiding me, reassuring me, reminding me to lighten up and to CHILL OUT. Most of the time, it is easy to hear. It is like we are partners on our walkie-talkies: "Go ahead...Copy...Over and out, good buddy." But then other times, Little Guru-Man seems too hard to reach. There is a lot of static on the line. But the only reason that happens is because *I* clutter it up with all my messy obsessing. When I just LET GO, I get the purest signals. And then everything works out, like magic. For example: I am running late. My body muscles tense, I am swearing, and I start to fling through my clothes in a panic to get ready. Then, in a moment of grace, I catch a glimpse of my crazed self in the mirror and remember to STOP, take a nice, deep breath, and proceed with calm. Twenty semi-peaceful minutes later, not only do I pull up to an excellent parking space, but there are three hours left on the meter AND the function I was supposed to be there early for turns out to be cancelled and (tah-dah!) I get a bonus day off. See? It all works out, like magic.

We celebrated my birthday last year in New York, my favorite city in the world, and I swear that the Universe, or God, or whatever you want to call it, was in on it, because this day was just too good to be some accident. I took the elevator up to the top floor of this shiny, four-star hotel we were staying in to check out the exercise room, and it was breath-

taking. I literally sucked in my breath when I stepped off the elevator. This room had windows, not walls, and I could see way out over the city, all the way to the river. "Man!" I thought, "I want to be out *there*, out on the roof itself, sucking up that fresh New York City air!" But I was certain the rooftop door was locked, and it was, of course. But as I was leaving, I noticed another door on the other side, and I am thinking, "Nah, it'll be locked, too. They lock it so that people like me don't go traipsing out there looking for pigeons to feed and fall off the side and die." But, heck, I had to at least try it. I mean, if we assumed that every closed door was a locked one, we'd never even make it out of the womb, am I right? So, just for kicks, I tried it… and it opened! Just like that. It did not even have a lock on the doorknob at all.

And I stood there, on the 47th floor of this gorgeous hotel in the middle of the most fantastic city in the world and I yelled "Thank You! (To what, I'm not sure, I only know I was not there alone.) THANK YOU!! for pouring so much joy into my life that sometimes I don't even know what to do with it all; THANK YOU!! for putting up with all of my whining and complaining and running around like a frightened little beaver, damming up the Flow with all of my lists and schemes and anxieties; THANK YOU!! for opening doors (that logically-speaking *should* be locked) and for pulling me out into surprising, new worlds, each one more spacious and astonishing than the last." I belted out my

favorite songs, all the way up into that brilliant spring sky, and then down to the little Matchbox cars on the street, and then over to the high-rise apartments that faced me, where some little old lady was peeking out at me from behind her blinds. I waved to her with attempted nonchalance and smiled my broadest, as if this wacky rooftop dance was merely my morning constitutional, the most normal thing in the world. And for that eternal stretch of moment, I dared believe it could be. My arms and legs, like four children after a long car ride, yearned to turn cartwheels, and so we did, springing back and forth across the concrete carpet. Then I jumped up to a higher, steel platform and began to sweep my arms in wide, rhythmic arcs up towards the sky. And then I stopped. My feet were tingling. My hands were pulsing and red. A tom-tom beat was thumping inside my chest, which rose and fell, rose and fell. I stood there, rooted as an ancient oak, and I felt my whole being swell up with fullness, happy just to be ALIVE.

ALIVE.

Our spirits are sails. Wide, white sails. And when we rise up in readiness to be filled, the breath of the Universe *always* comes blowing. Full. Powerful. A divine wind is blowing. Blowing. And here we go, headed straight out to sea...

Joy Blythe is an actress, artist and adventurist who is learning and teaching about how to live a successful and prosperous life. Her various life employments include cashiering at a grocery store, selling women's clothing at the mall, juicing carrots at a juice bar, and attending a flower stand. She has waitressed at a Chinese restaurant, a Mexican restaurant, a seafood restaurant, a tropical bar, and a pancake house, and she has also served as a bartender, a data entry clerk, a fairy godmother, a hotel housekeeper, a U.S. census taker, a large dancing kangaroo, and Sneezy the Dwarf. All of her experiences and travels throughout this country, and in Central America, have helped her to find her True Purpose, as well as a goofy sense of humor. She currently lives and plays in Charlotte, NC. She tips well.

Clarity Cometh

In July 2002, twenty-two months after the opening night of "Let the Stories Move You," Powerstories Theatre began the process of discovering a new group of women to perform in a second show. This time, there was a record of accomplishments and Fran could speak more clearly about expectations and give better examples of the upcoming successes and challenges. Women knew the work involved, but were still interested in volunteering and sharing a piece of their lives with others.

This time around, Powerstories held auditions in two cities across the bay from each other, Tampa and St. Petersburg. The process for selecting women remained the same as Fran continued to seek women who were very clear that they had an inspirational story to share with others.

The first round of auditions was held in a large new theatre in St. Petersburg. The women walked up on the huge empty stage and told stories of career change, empty nest syndrome, pain after the death of a family member, and love for a daughter. Several women came up to the stage and read their prepared stories, others spoke impromptu. A few women held their papers with a death grip only to watch the paper shake so violently they had trouble reading the words. One woman came to audition, but did not get the courage to tell her story until a month later.

The second round of auditions was held on a very stormy night in Tampa in a cavernous old warehouse with a tin roof. One woman began her audition in a quiet theater and finished by screaming over the sound of rain pounding on the tin roof. Just as the rain finally subsided, the lights went out. The women found one tiny room in the corner of the warehouse and huddled together to continue the auditions.

A new cast of eight women was selected. On March 14, 2003, they gathered in an old church converted into a small theatre in East Tampa to finally read the new script. They sat in white plastic chairs in a circle to read their parts in "Clarity Cometh," laughing and commenting as they got the first glimpse of how their stories would be woven together into one cohesive piece.

Opening night finally came for them, too, and like the women of "Let the Stories Move You," they stood backstage in a circle to calm their nerves about performing for the first time on stage. These are their stories.

Dream New Dreams

Stefani Busanski

Over and over the lyrics to this old Beatles song repeat themselves in my head and suddenly I find myself almost subconsciously singing them out loud as I drive my three-year-old daughter to preschool. *Blackbird singing in the dead of night, take these broken wings and learn to fly...all your life, you were only waiting for this moment to arise.*

From the back of the van I hear my daughter ask, "Did you sing that to me when I was a baby?"

"No, that's one of Mommy's songs."

"What songs did you sing me?"

"When you were a tiny baby I sang you 'We All Live In A Yellow Submarine' and 'You Are My Sunshine.'"

"Mommy tell me about when I was a baby."

For most of my adult life I was desperately trying not to get pregnant until I met a nice Jewish guy and bada bing bada....well it wasn't actually that easy. It was more like a series of telephone conversations over a five-year span that culminated in marriage and pregnancy. It went something like this:

"Mom, I don't want to meet your boss's son. I'm engaged to someone else, remember?"

"Oh, hi, Ed. Yes, she told me you'd be calling. Sure, I'd love to go see a movie with you and your girlfriend."

"Mom, yes, I'm positive. We're just friends!"

"Sure, Ed, that sounds good. Dinner tonight...just the two of us?"

"Uh, Mom, Ed and I are buying a house together, but we're not getting married..."

"Honey, I know, I know, but we can't have pork loin at the reception. We're Jewish!"

Ultimately, after two years of being friends and two years of dating, we had a big Jewish wedding. About two years later, we were expecting our first baby on July 25th, 1999.

I continued working as the Educational Director at a facility for adults with mental illness. I played tennis once a week and tried to eat right, although I had simultaneous cravings for sausage and sour gummy bears with a Slurpee chaser every day around 4 pm. My husband joked that the baby's name should be Patty or Link! We painted a used crib and changing table with baby safe paint and waited for our little bundle to arrive. On April 20,

1999, just about when I was starting to wear pants with elastic waists, I woke up at 4:30 a.m., soaking wet from the bottom down. I thought I'd wet the bed, so I grabbed some dry pajamas and slunk off to the bathroom trying not to wake my husband. I sat on the toilet looking in my *What to Expect When You're Expecting* book under Loss of Bladder Control. I realized after a few minutes that this was not the problem and quietly walked back in the bedroom to wake him up with news that would change both our lives forever.

"Honey.... Honey.... Ed, wake up!"

"Whaaasamadder?"

"Something's wrong."

Something was wrong all right. He whisked me off to the hospital. When we arrived, the nurse immediately put me flat on my back and went to call my doctor. Before she left, I asked to use the bathroom. "That wouldn't be a good idea, dear." What? I had visions of the baby just falling to the floor if I stood up but according to my friends with kids childbirth wasn't *that* easy. The nurse brought me a bedpan so small she must have borrowed it from Emergency Room Barbie and proceeded to tell me that congratulations my water had broken 3 months too early and I was to be a guest on the High Risk pregnancy floor until the baby was born. I asked for a pack of matches and proceeded to burn my *What To Expect When You're Expecting* book.

"Mommy?"

"Yes, Sarah."

"Was I a girl baby or a boy baby?"

A few days after being admitted to the hospital, my husband and I were talking when a loud, rather voluptuous nurse came in the room to get my "vitals."

"You know I can tell you the sex of your baby if you want," she said.

"No, that's okay...we want to be surprised," we replied.

She then proceeded to tell us that we were probably making the right decision because in her experience premature white boys usually were the weakest babies while white girls were stronger and had a better rate of survival. She said the strongest preemies were black girls. Well, I took one look at my lily-white skin and that of my husband's and thought the likelihood that we're having a black baby of any sex wasn't good, so we opted not to find out at all. I secretly thought it was a girl all along but I didn't want the baby to feel bad if it was white and happened to have a penis, so I just concentrated on keeping whoever it was inside me for as long as possible. Shortly after the nurse's startling revelation, a pediatric neurologist came to visit to tell us in his I-do-this-every-day-so-sorry-it-happened-to-you-but-it's-medically-fascinating-to-me tone that our baby could have thousands of deformities and complications but "don't worry, try to be positive and I'll see you tomorrow."

I switched on the television and learned that earlier that day two students had gone on a killing

spree at Columbine High School. How were we sup-
posed to stay positive when the world was coming
to an end? I decided not to watch anything but the
Discovery Channel for the rest of my stint as a
human incubator.

My time on bed rest was a flurry of activity —
only it was all happening around me while I rested
in a horizontal position unable to sit up for more
than 45 minutes at a time. I got a haircut, picked out
awnings for our house, was monitored, poked and
prodded at every hour of the day and even made a
few hundred favors for my sister's upcoming wed-
ding. My friends and family came by every day to
bring me things to do, wonderful food from the
"outside" and cheery happy faces that belied their
worry and concern for the baby and me. My hus-
band rubbed my back, bought me a Game Boy and
even emptied my bedpans on occasion when the
nurses weren't around. The medical facts of this
story are fairly boring, let's just say that not being
vertical for three weeks can change a person.

I learned to have a conversation while sitting on
a bedpan, I learned how those Rastafarians make
their hair do that, and I learned that true friends
bring you takeout from Outback instead of flowers.
Things were looking pretty good for Baby X and me
until a few hours before midnight on May 5th. My
husband and I were actually having a small dis-
agreement about finding out the sex of the baby dur-
ing a particularly interesting show on the migration
patterns of the flightless emu when I started feeling

really sick. At first I blamed it on the hospital food but soon realized that our baby had decided to make its appearance and settle this silly argument between his or her parents once and for all. I urged my husband to find a bucket.

"Honey, I'm lookin' all over but I don't see any buckets."

"A bowl?"

"Nope, don't see one."

"Container?"

"Uhh-Uhh."

"Okay, Ed, how about any sort of receptacle than could catch tonight's Chicken Kiev Surprise?" Sometimes men can be so literal!

Honestly, I don't remember much after that. A crew of doctors and nurses tried very hard to stop the baby from coming but Sarah Helen made her appearance at 4:29am on May 6, 1999 weighing 2 pounds and 11 oz. She was 14 inches long. Not that much bigger than Emergency Room Barbie! For three days, I had a high fever and wasn't allowed to see her. My husband bought a Polaroid and would go back and forth from the Neonatal Intensive Care Unit (NICU) bringing me the latest pictures of our tiny miracle with the full head of black hair that made her look like a miniature Elvis. The first time I saw her I put my finger through the tiny opening in the incubator and sang the only songs that came to mind those first few minutes, "Yellow Submarine" and "You Are My Sunshine."

We left the hospital with a free gift of formula and diaper bag, but no baby. We were still hopeful that everything would be all right and returned each day to see how much she weighed, hold her, sing, teach her to suck from a bottle and commiserate with the other parents of premature babies who were milling about the incubator-filled unit at all hours. We experienced joy and sadness as some babies improved and some did not and never would. One day I witnessed a family saying goodbye to their baby. Everyone was crying, even the nurses. I will never forget the young father dressing the baby in a beautiful white gown to wear at his funeral.

Fortunately, Sarah was a very strong and willful preemie, even for a white girl. The NICU nurses nicknamed her Firecracker because of her loud protests when they would disturb her for tests and for her habit of resting her hand on the incubator latch as if to say, "When you guys aren't looking, I'm breakin' outa this joint!" She came home after just six weeks in intensive care weighing a whopping four pounds. Even though she was wired up to a heart and lung monitor we took her everywhere. To people's stares and concerned curiosity, we responded, "Oh, her, she's bionic."

We eventually forgot what the pediatric neurologist told us about things that could go wrong with premature babies and just kept thinking positive thoughts and feeling just plain lucky to have her at all. The newborn stage was typical: colic, midnight feedings, sleep deprivation and hours of staring at

her in wonder, hoping that our pediatrician was cor-
rect in his prediction that she would eventually catch
up.

After eight months, it was clear that she was not
developing normally, so we started taking her to
physical therapy and sought the advice of our pedi-
atric neurologist. He recommended having an MRI
done, which we avoided for several months after his
consultation. But all good stages of denial must
come to an end. I actually paid a psychiatrist good
money to tell me that. Eventually, and I say eventu-
ally because what we immediately did was go into
that other stage of denial called I - can't - face - this
- can- you - let's – order - pizza - and - act - like -
nothing's - wrong.... that cost us another $2000
worth of therapy. In April 2001, my husband and I
sat staring at each other while our tiny baby under-
went a brain scan to determine the extent of neuro-
logical damage she may have suffered due to her
premature birth. Two weeks later, we found out that
Sarah had cerebral palsy, which affects her ability to
sit, stand and walk.

My husband and I spent months researching
new treatments, taking her to new doctors and ther-
apists and repeatedly staring at the computer screen
looking for help on the Internet. We grew apart
physically and emotionally because we couldn't fig-
ure out how to deal with the grief for our lost expec-
tations of having a normal baby. I was extremely
angry and explosive. At times, I was guilt ridden.
Maybe I shouldn't have played tennis that time with

the woman who said, "Oh, I didn't know you were pregnant. I just thought you'd gained some weight." Maybe Baby Jesus was looking down from heaven saying, "I told you not to convert to Judaism. See what happened!" I shouldn't have sneaked into the bathroom that one time when I was on bed rest just because I longed to relieve myself in a vertical position. These thoughts came in waves mostly at night and early morning...they were irrational and relentless. I threw things, yelled and screamed at the husband I was supposed to love and cherish, and cried in the bathroom by myself. Most days I felt guilty for feeling a sense of loss when we had this beautiful, bright and happy child right in front of us bringing us so much joy and pleasure. And then, I heard an old Beatles song that helped me change my way of thinking.

Blackbird singing in the dead of night, take these sunken eyes and learn to see. All your life...you were only waiting for this moment to be free.

"Mommy, can I have another book?"

It was about 3 months after we'd received Sarah's diagnosis. She was two years old and I had accepted a friend's invitation to join a playgroup at our neighborhood park. My friends were constantly starting and stopping quasi-adult conversation to chase their children around while I sat quietly reading to Sarah in her wheelchair on the sidelines. They came back complaining about how active their kids

were, which brought me close to tears as I imagined ever having to scold Sarah for running away from me. There go my expectations again. Will Sarah be able to play by herself? Will she have sleepovers? How will she experience nature if she can't walk through the woods? Don't get me wrong...most of the time we concentrate on what she can do but I'm sitting on this park bench surrounded by walking, running children playing in the sand that is inaccessible to my daughter who is perfectly content reading her books watching the other kids play. But I'm not content at all. Why? That pesky little list of EXPECTATIONS and WHY MES from the book What to Expect When Your Not Expecting What You Get? You know what I'm talking about. Why, why can my best friend eat a five pound piece of fudge and look like a twig when I break out and gain ten pounds just watching her? Why can't my baby sit up? Should I expect to ever get back into those size 8 jeans that taunt me in the back of the closet? Why can't there be a playground for all children to play together? Why after five years of marriage do I still expect my husband to look up from the morning paper when I walk in the room? Suddenly, this ridiculous train of thought is broken by a question.

"Why is she in that wheelchair?"

I begin explaining cerebral palsy and the reason Sarah wears braces to a little girl that's come up to her on the playground.

Her eyes start glazing over and she interrupts, "Well, can she play?"

Sarah turns to me asking me everything with just one look. "Mommy, I can play, right?"

The question is heartbreaking. Sarah isn't asking me permission to play with the little girl. She is actually wondering if she can physically play and I don't know what to tell her. In those few seconds, a five year old has inspired me to stop thinking about my expectations for Sarah because it's not about me at all. My grief, depression and worry about lost expectations is mine alone it has nothing to do with this incredible two year old who looks at the world as full of possibility, not limitations.

I started dreaming of a fully accessible playground where all children regardless of ability can experience the freedom and joy of playing together. Sarah's physical therapist helped me find a group to support the project, the mayor gave his blessing and over 1,000 people came forward with donations. Suddenly Freedom Playground was born — the first fully integrated barrier-free playground in my community. My daughter has taught me something very important about living: finding and using our abilities is a lot more productive than focusing on our disabilities. What you have is so much more important than what you are missing. I am learning to lose my old expectations and dream new dreams.

Blackbird fly, blackbird fly...into the light of a dark black night. Blackbird fly, blackbird fly...into the light of a dark black night.

"Mommy?"

"Yes, Sarah?"

"I decided I don't want a playground, I just want to go to the library!"

See...it's not about me at all!

Stefani Busansky comes from a long line of storytellers and began formulating her own stories at an early age….she didn't realize they could be misconstrued as lies until one of her "stories" got her in trouble when her mother found out she'd been walking to the playground instead of piano lessons every week. Over $300,000 has been raised to date to build Freedom Playground and now the original grassroots committee has formed a non-profit corporation, Freedom Playground Foundation, Inc., to help other groups build accessible playgrounds. Currently, Stefani can be found playing with her two beautiful daughters, Sarah and Claire, and her husband, Ed, in Tampa, Florida. She still sees and talks to blackbirds almost every day!

Making Miracles

Melissa Schultz

It started out like every other cold January day: I woke up to loud music coming from my alarm and opened my eyes just enough to see the frost outside my window. I rolled over, cuddled my pink down comforter, and slapped the snooze button. When I finally rolled over my stuffed animals to get out of bed, I was already running late for school. I made a dash for my bathroom to splash on some lotion and perfume, stepped into my walk-in closet to find my favorite dress, and grabbed my cheerleading bag. I put on all the Cleveland winter accessories, including earmuffs so as to not make a mess of my hair, and I flew out the door without even a bite to eat. I brushed the snow off my new sporty white Civic and drove to pick up my best friend and my

boyfriend and we raced to school. We hurried to homeroom and made up some excuse for our tardiness. High School.

School was the same old thing, different day. I had my normal classes, professors, friends, and, of course, high school gossip. Near lunchtime, I began having stomach pains. They were nothing severe and I blamed them on the normal monthly cause. I had cheerleading practice after school to get ready for the weekend game. I still had the pain, but ignored it in order to concentrate on our new routine. Just as practice was finishing, I started to get dizzy. We had just finished the final run-through of the routine, and I attributed the light-headedness to standing up from the ground too fast. I put my hand on the wall to give me balance, and shook off the nausea. I drove home, but the closer I got, the worse I felt. It was like that two mile drive home was the equivalent of a flight cross country. I couldn't make it back to my comfy bed quick enough. I got home and mom immediately noticed that something was wrong. Just wanting to be alone, I went off to my room, grabbed my stuffed dog, John-John, and tried to get some rest. I closed my eyes but couldn't sleep. The pain increased and the only way I could lay comfortably was in the fetal position with my knees up under my chest.

After about thirty minutes, I had to use the restroom. I could barely move and I knew it wasn't going to be easy. I stood up, walked into the bathroom, and as I sat down I felt as though I was being

stabbed in the side yet I had to vomit at the same time. I let out a scream that could wake the neighbors, calling for my mom. That was the last thing I remember.

When I awoke, I opened my heavy eyes and saw the reflection of my step-dad holding me up. I could hear my mom hysterical on the telephone. He screamed that I was awake. The next few minutes were a chaotic frenzy. Mom was running around trying to get me dressed, but I had no interest in it. I still was not thinking straight: I thought it was fine to go out in the winter cold wearing my blue and yellow ducky shorts and a tank top. Confused, I began to cry, and then the paramedics arrived to take my vitals. They said that I looked stable, so mom drove us to the hospital.

The hospital was a blur of questions and tests. I had an ultrasound, blood tests, and finally a CAT scan. It turned out I had a mass in my abdomen that had erupted. I was told that I needed to have a biopsy before I was rushed to surgery. At the time, I didn't think much of it, since I knew they were going to put me to sleep, and that was all I wanted to do anyway.

On the third day after my surgery, I was slowly recovering but still didn't know anything. I remember waking up and glancing over to my left to find my mom looking out the window. She was always there with me. It must have been the way she was standing and looking out the window, so contemplative and deep in thought that made me ask, "Mom,

but what if it's something bad, like what if it's cancer?"

The question changed her slumped posture, as she stood up tall, walked with purpose over to my bedside, took my hand and looked me in the eye.

"Then we'll deal with it, honey," she answered.

I cried. I wanted my mom to comfort me by telling me that it couldn't be something as bad as cancer, but she didn't. I knew right then that I was not the healthy girl I thought I was. My mind flashed to all of my so-called problems up to that point: boyfriends, cheerleading, high school gossip. My biggest crisis was when "Beverly Hills 90210" was a re-run.

I heard a rustle coming from the doorway and turned to find my father, stepfather, and a team of doctors pushing their way into my room. The look on the faces of my family put a knot in my stomach — I felt as if I just had the wind knocked out of me. Both of my strong fathers had the look of scared little boys. I could tell they had been crying by the their rosy cheeks and swollen eyes. They looked as if they had both been out in a snowstorm for hours. But that was not all I saw. As I looked into their eyes, I did see a gleam of hope. There was a comforting knowledge hiding behind their tears, and I felt at ease watching my father make a small nod to my mom while the end of the right side of his face turned upward into a half smile. That was his way of letting her know that all was not lost. I didn't know what their interactions were about, but I took it all in

as this was the moment I had been waiting for. Now I was going to find out the reason I changed from a healthy young teenager into a sick, bedridden child. The doctors crowded around my bed as my mom grabbed one of my hands and my dad took the other. My step-dad walked to the side of the bed and put his hands on my shoulders. My gaze went directly to the doctor in the center.

He took a deep breath as if he was asking a higher being to give him the strength to continue. "Melissa, you have cancer. It's a yolk sac tumor-germ cell cancer that has been in your system since birth. There is no way of telling how long it's been cancerous."

He continued on, but I didn't understand any-thing else that he was saying. It was almost like I was a character in the "Twilight Zone" and I could no longer comprehend what anyone was saying and I had to rely on visuals. I first looked to my parents: all three appeared to be relieved. That's when the confusion set in. The only thing I heard was, "Melissa, you have cancer!" I couldn't imagine that phrase being comforting to anyone. I again saw that gleam of hope, now it was in the eyes of everyone in the room. They were all comforted and relieved by something that the doctor was saying, but what he said, I didn't know. My mom continued to fight back tears and she squeezed my hand as though she was transferring all of her strength to me. My dad also squeezed my hand and smiled as he allowed the salty tears to stream down his cheeks. My step-dad

drew closer to my mother and threw his arms around her, comforting himself as much as her. There we were, the four of us, all holding on to one another as if to send a message of hope. We were an army of four that was ready to use everything we had in order to get through whatever this diagnosis brought. This was not the end; cancer was not going to be my death sentence, and we were just letting everyone know that.

I recovered for a week after the abdominal surgery and was then moved to the oncology floor. I vividly remember the nurses' laughter as they brought down additional carts to move all of my belongings. I had two carts of beautiful flowers, another filled with cards and letters, and a bed filled with stuffed animals. They actually called someone to wheel me upstairs because I couldn't fit on my own bed with all of my new fluffy creatures.

I moved to my new room and my parents helped me decorate it as my own. We had photographs of friends and family on all four walls, a stack of movies taller than the television, and my radio in the corner. Of course, there were also my fan letters. Pictures from my siblings covered my walls and door, while cards from all of my friends and teachers hung around the room. I was so lucky to be surrounded by such great love.

Although it sounds great, I was just beginning to make the best of a bad situation. In a conference with the doctors, we were told that my course of treatment was going to be five days on chemothera-

py, and then three weeks off. I would stay in the hospital for 5-6 days to get my treatment, and I would be sent home for the three weeks to recover. With that, as soon as my immune system would recover from the chemotherapy, we would go back to the hospital to hit it again.

One day during my first week home from the hospital, I was standing in my pretty pink bathroom running the comb through my long blonde hair. I was getting ready to go to lunch with a good friend of mine. We were going to stop by my high school to pick up some things I needed for graduation, and then get a bite to eat. That's when it happened. As I brushed my hair, it began coming out in chunks. I was pulling handfuls of hair from my head. My eyes got wide and I yelled for my mom.

I had always thought that I was a cute girl, but I no longer felt that way. With the loss of my hair, I felt a loss of femininity. I looked in the mirror and cried because I didn't see myself anymore. The reflection in the mirror was not the cute, young, happy, and healthy girl I knew, but a sickly looking stranger that was much too thin from illness with a shiny, bald head to remind others of her illness. Even after my hair came back, my self-confidence didn't. For a long time I would not wear skirts or dresses, a prior staple in my wardrobe. I didn't want to dress pretty because I didn't feel pretty.

I got through that six months as best I could. While going back and forth to the hospital, I tried to be a normal teenager. Of course, there were a few

exceptions. Instead of worrying about how to wear my hair to prom, I had to pick which wig to wear and how to hang out around my friends yet avoid infection. And what friends I did have. My best friend, Heather, was always finding some way to get out of school to come visit me. She actually had her classes re-arranged so she would have lunch and study hall at the end of the day. She then got the principal to excuse her from those so she could visit me. I couldn't even guess how many miles she put on her car going back and forth to both my house and the hospital. And if you think that having a best friend that is always sick and nauseous could keep us from hanging out, you've got that wrong. Instead, we just adapted. Heather would keep a fresh supply of plastic grocery bags on her car floor, so when the moment inevitably came that I felt like I was going to be sick, she was always prepared.

Then there was Aunt Doddy who would come to the hospitals to do sleepovers, when I needed a change. She would watch movies with me, bring all kinds of goodies to the room, and even rub my feet to make me feel better. And the time Uncle Mike went out of his way on a day off to bring me the Taco Bell concoction that sounded good to me at the moment. My room was never lonely because I was always surrounded by family and friends. I was always so lucky to be surrounded by such love.

In June of 1997, I was finally finished with chemo and my second abdominal surgery. I graduated from high school in the top twenty of my class

and got ready to go to college…now "cancer free." But you can never be free of the experience of having cancer. During college, I decided to go back to the hospital to volunteer. I took a deep breath and marched right up to the cancer floor where I would be doing my volunteer work. It was then that I saw Pepsi again. Pepsi was a young girl about my age and she had cancer too, but her case was terminal. Pepsi and I would go to the game room to play board games, do crafts or watch movies. We were hospital friends, and I almost felt guilty looking at her growing more ill in bed as I stood tall with my blond hair beginning to grow back. Being with her again reminded me that I was one of the lucky ones, one of the miracles.

During my bout with cancer, I was always grateful that I was the one going through the treatment. I didn't feel that I was strong enough to watch someone that I loved go through something so terrible, knowing there was nothing I could do to help them. In my senior year of college, just like in my senior year of high school, I would find out just how strong I was.

One day after classes, I returned to my dorm to find a message from my new boyfriend. He sounded very weak and the message sounded urgent. I rushed to his dorm room, and stared in disbelief at the thermometer that read 105.1 degrees. He was sweating profusely and his skin felt cold and clammy to the touch. I knew we had to get him to the hospital. We drove to the emergency room and wait-

ed for what seemed like hours. I began to get angry and hostile, watching the doctors take back people with ear infections and little coughs. I know now that they could have had a number of different ailments, but at the time I didn't care. I wasn't thinking straight and all I knew was that my boyfriend was very ill and we weren't getting any attention. After we were taken back for hours of tests and waiting, we were sent home with no answers.

Two months later as we sat in the cold doctor's office for Brian's quarterly exam, the doctor questioned us, "Did the emergency room doctors say anything about your liver tests?"

Of course they hadn't. The doctor explained to us that Brian's liver enzymes were off the charts. For six months, Brian was given a specific diet and his blood was closely monitored. He became our designated driver, but his liver tests kept coming back worse. After the six months, the doctor recommended a biopsy and a week later, we were given the news.

"I don't know how to say this, but you're going to need a liver transplant in the next one to two years," the doctor explained soberly.

Can you believe it? Brian was 20 years old and needed a liver transplant. We stood there shocked, but prepared. I had already been through a life-threatening illness and I was going to help him get through his. We graduated from college, moved from Cleveland to Tampa, and found the best transplant center in the area. We got him on the list and

waited. The call came February 27, 2002 and we were told the procedure could happen the next morning. It did and Brian recovered beautifully!

During his recovery, I was able to use many of my experiences to make things easier for him. I could prepare him for the pain and give him tips on minimizing it. We are stronger now because of the things we've endured, together and separately, and my cancer experience helped make his experience just a little more bearable.

It's one thing to help those you love, your friends and family. I think the greater challenge is to help complete strangers. I don't ever want to forget how lucky I have been and how important others have been to me during my challenging times. In June of 2002, I decided I needed to continue to give back. It wasn't enough to help those I was closest to; I also needed to extend what I had learned to others. I joined "Team In Training," a fundraising event for the Leukemia and Lymphoma Society. Participants are trained by coaches to complete an endurance event while raising money for this worthy cause. I chose to do the Disney Marathon and I committed to raising over $2,000 in the fight against these blood-related cancers. The training and fundraising were difficult, but it was nothing compared to what patients with these diseases go through everyday.

And guess what? Brian and I got married in April 2003. I married my best friend and one of the strongest people I know. I am also proud to announce that I am a new Community

Representative with the American Cancer Society. I work with the Society in community education and income development, and I've never felt better about getting up every morning. I am so happy, and, yes, I do know that I am on the right path.

We all go through hard times, and I am so thankful that I had to endure these challenges. They kept me present, strong, and grateful for each and every day. If we all can make the choice to use our negative experiences in a positive way, we might just leave this world a little better than we found it. "Where there is great love, there are always miracles." I never want to lose sight of that.

While working in medical sales, **Melissa Schultz** discovered Powerstories. With Powerstories she found the way to touch others through telling her story. Melissa also discovered that her passion lies in helping others. With the help of her Powerstories experiences, Melissa left a comfortable position in medical sales to pursue her dream of working for the American Cancer Society. Melissa is now a Community Representative with the American Cancer Society working in income development and community education.

Welcome

Magda Santos

Hello, and welcome to my world.

In my world, there are people of many colors, from many parts of the world. There are people with abilities and disabilities, different sexual orientations and different points of view. There are animals, rocks, trees and insects.

As a matter of fact, my family is a rainbow of colors. My maternal grandmother, that's my mother's mother, looks like a Spaniard. She has white skin, green eyes, and straight hair. My mother looks like her mother.

Both my grandfathers had dark reddish skin like the native people of Puerto Rico. One had what some call kinky hair or very curly hair, and the other

had dead straight hair. My father has really curly hair and skin the color of caramel candy. His eyes are dark brown and they laugh when he smiles.

When I was born, my great aunt checked my small body for what was call "la mancha de Negro," or the sign of being black. After that my brown skinned father left us. My guess is that he didn't feel welcome.

At seven, I began living with a Puerto Rican-German stepfather. He spent every day telling me I was going to grow into an ugly, large-nosed black woman. What bothered me the most was not looking like an African-American woman, it was turning into an ugly woman. I thought I was cute. Much later, when I was fourteen, my mother divorced him. But before he left, he gave me the greatest gift I have ever received: a white-skinned, straight-haired, little sister. I became her teacher, protector, and friend. I still talk to her every day.

As a young girl, I lived in Newark, New Jersey. It was the sixties and there were riots brewing in the city. Newark was in a state of alert. It felt like a kettle of water about to blow. One day when I was 8 years old, my mother got a call from my elementary school asking her to pick me up. Community leaders had sent word to school administrators that violence was about to break out. The schools scrambled to evacuate all their students. My mother worked in New York City on 14th Street just off of 8th Avenue and it took her longer to get to school than the other parents. She arrived breathless and in a panic, think-

ing I might be hurt. But she found me alone swinging on a swing in the playground. When she asked me if I was all right, I said, "Si, mama, yo estoy bien." "Yes, Mother, I'm okay." But she continued asking questions. Perhaps it's because she knows more about internal wounds and scars than most. She wanted to make sure I was really okay.

What finally put her mind to rest was what I told her had happened when the playground polarized into two groups, the black students on one side and the white students on the other. I told her that I'd simply said, "I'm brown, not white or black, and I don't know who I belong to." Both groups decided it was too complicated to figure out where I belonged and agreed I should stay out of the quarrel. Nothing happened in the playground, perhaps having to stop and think about brown vs. black and white took too long and we were sent home. I don't remember. However, by the end of the day, the city burned.

Later that year, we moved to Hillsdale, New Jersey, a small white town where there are more millionaires per capita than in most countries. My puffy brown braid and extra long legs carried me to school each day. And each day, I felt I was all alone and in danger. There were no brown people anywhere. Not in my home. Not down the street. Not on television. And on top of that, everyone wanted to know why I was there. Who was I? Why was I in their town? Why was I brown? Why did I have super curly hair? I was scared and I certainly didn't feel welcome.

By now, I had witnessed the assassination of a president and a civil rights leader, a war, and the civil rights movement in living color and in all their horror courtesy of network television. I was struggling to find ways to deal with all the questions, violence, and insensitivity. I felt my heart folding into itself. Disappearing. But even then I knew I wasn't destined to be a sad, angry person. I needed to find ways to stay openhearted. I looked around me and chose joyous people to emulate and the spirit of a beautiful stream to soothe me. I spent hours by the stream that ran through the town of Hillsdale and every day I asked for help and hoped for peace and safety as I sat on its bank.

Interestingly enough, my white elementary school teachers in Hillsdale gave me clues to not only surviving but also understanding how to live in such violent, hateful times. They used movies to teach tolerance. The first of the two films I remember the most was "Eye Of the Beholder." It showed a series of events from several points of view. I sat with wide-eyed wonder, taking in the message of the movie. If you looked at it one way it was a murder, another it was a love story, in yet another an artist was inspired to create. It struck me that perspective or point of view could be a stumbling block to understanding stories, cultures, and people.

The other movie was "Nanook of the North." It was an investigation into the Inuit culture of Alaska and Eskimos. I watched the native people of Alaska wake up in the morning, get dressed, eat, hunt, and

live their lives. It gave me an opportunity to appreciate the differences and similarities between our cultures. It gave me a sense of respect and an understanding of why there are differences among us at all. I mean a brownstone in Alaska wouldn't work well but an igloo in New York City would be tragic.

Armed with this new information, I knew I had to decide whether I was going to stand ready to fight off the blows of the many narrow-minded people I would continue to encounter, or welcome life with both arms open. Fighting would make me look cool and offered me protection. But like the reluctant heroes of American cinema, I knew welcoming life was actually the bigger challenge and I had to take it. I naively thought I would make this decision once and never think about it again, but I was wrong. The confrontations became more personal and hurtful. The decision to welcome the world no matter what it offered didn't come easy and I had to revise my thinking and emotions as I reached each of my life's milestones. Perhaps I shouldn't have read Sartre in high school. It took me most of my existentialist teenage years to really become comfortable with the idea of opening my arms to the world.

As I grew and changed, I had to adapt to new threats. Every time I was about to make a "final" decision about remaining welcoming and throwing my arms open to the world, something would happen to anger me. Like the time I went to dinner at Pat's house when I was in my twenties. She was a wonderful Italian cook. Her family is from southern

Italy and I enjoyed her stories about Wall Street and being an extra in the movies. Her Murphy bed was tucked away and the couch and living room chairs were moved to make way for all of us. We were having a great time. An aromatic Sicilian dish was served to each of us at a huge table in her studio apartment. I was twirling my pasta when a friend of hers started talking about her children. I was listening carefully because there was a quality to her voice that told me there would be something important coming up soon. And there was. I was the only one of color at the table. She began blaming me for the fact that her youngest son did not go to college. It seems it was my fault he could not pay for school. She felt I must have taken his place. It was the late eighties and affirmative action was the buzzword for most angry whites. Then the other guests began agreeing with her and wanted me to justify myself. I could feel the fight begin to emerge again. I guess I could have told them that my SAT scores and grades guaranteed me a place in most schools but I chose to say, "I don't have to justify myself to anyone but God, thank you very much, pass the spaghetti."

It was surprising how calm I felt as I answered my fellow guests, but my date was becoming outraged on my behalf, as the comments became attacks. I placed my hand on her arm. She suddenly stopped talking and looked at me. I was so grateful she wanted to defend me. But I knew it was my responsibility to answer them. I found my wit and

chose to leave them with a provocative answer. I chose to bypass all the petty details and remind them, by invoking God as a superior being, that justifying my life to them was not something they had a right to ask for. Their arrogance was not something I would accept. And the sense of privilege that gave them the comfort to ask me to justify myself was not something I recognized. The conversation at the dinner table moved on to gentler things.

My date turned out to be the woman I fell in love with, married and lived with for 18 years. She was an Icelandic-Jewish American with green eyes. She reminded me of my maternal grandmother, in looks and spirit. This time, I felt I needed to fight for our right to love each other. Sometimes I forget that within my lifetime, African Americans were subject to Jim Crow Laws and denied not only the right to vote but later denied their rights under the GI Bill. And the Stonewall Riot, when gays said no more to the police brutality in New York City, happened only a decade ago. I imagine many a high heel was broken on that day.

Still, I was in an interracial lesbian relationship. Fight or welcome everything that comes my way? I have had to defend myself at dinner parties, meetings, and at work, never knowing when my very existence would be questioned. I have chosen to be myself and that seems to be a threat to some and a joy to others. To keep my balance between these two reactions I have had to stay focused on my truth.

What tipped the scales for me was that I found wonderful teachers everywhere. They were placed throughout my life like steppingstones. They kept me above the muddy waters and the quicksand. They moved me forward on a path of peaceful existence. They were the examples of blissful living I saw ever since I was a child.

Some teachers were in the form of people, like the yoga lady on television, who gave me my first lessons in breathing, stretching, and body control, and Mr. Cohen, who saved me from an uninspiring inner city high school and gave me the world of art, archeology, and theatre. He took me to lunch at the Metropolitan Museum of Art in New York City. We hung out with the conservational archeologist in Paterson, New Jersey and dug for artifacts. We saw a play, on Off Off Broadway.

Vin introduced me to teachers that came in other forms. In my thirties I met Vin, a short, muscular, dark man with a contagious laugh, who brought me the power and beauty of the Native American way. I began studying with him and after twelve years received his highest honor, a single eagle feather. Vin left me with an understanding of how I am connected to the world around me. This relationship to all things natural allows me my daily rituals, like having morning coffee with a heron. I live in an apartment complex in Brandon, Florida and almost every morning I open my apartment door and watch a beautiful heron standing on my perfectly manicured lawn that leads down to the lake. I sit

on my fluffy couch with my coffee and watch her. There is nothing else in my life like her. She brings feelings of peace and stillness. She also challenges me to learn about her and the home we share. She forces me to think of the food she eats and if she has enough not just to survive but to thrive. She demands that I care about the cleanliness of the air and water for both our sakes.

Looking back, I see that I have walked on a path toward peace in my life. It has taken me forty-six years to reach this point. Of course there is much more to learn, but today I am a woman who devotes her life to helping others feel welcome in this world. I am a teacher like the teachers that were so important to me. It's clear to me that teachers can be agents of change and I want to be an agent of change. Today, I'm a motivational speaker who talks about the joy of learning. In my speeches, I remind my audiences to share their gifts. I encourage them to use their strengths to help themselves and others. I challenge them to find teachers everywhere they go. And most important, I invite them to join me in opening their arms and hearts to all their fellow earthlings.

So, welcome. Welcome to my world.

Magda Santos is a passionate teacher, author, and motivational speaker who finds lessons and stories in everyday occurrences. Twelve years of studying Native American philosophy and her work with Chi Kung have given her an insight into her own spirituality that makes her academic interest transcend paper and pen. When Magda is not learning or teaching she is taking photographs, performing on stage or writing. Her spoken word performances for Women Artists Rising are passionate and insightful stories and poetry.

The Asphalt Warrior

Michelle Sauvaget Juristo

I was eight years old and I would often create and design new roads with my yellow chalk again and again on the grey pavement. During World War II in Paris, the streets were mostly deserted and I was lonely. From the sidewalk, feeling the fresh air on my face, I frequently experienced the desire to leap to the center of the street and float in the air, like joining the flock of sparrows perched on the elm trees in the private courtyard across the street and flying away with them.

One day my grandmother, Louise, saw my art on asphalt and said "Mimi," she always called me by my childhood name, "you need to learn something useful. I shall teach you how to knit." I loved the repetitious rhythms of the needles playing

against each other. Knitting was a solitary occupation and I enjoyed the process, the daydreaming element of it, the journey. I really loved knitting!

As I became older, I still enjoyed process and repetition. Through the years I practiced meditation, classical ballet, modern dance, and yoga...but only a few days of ballroom dancing. I have practiced martial arts for twelve years. Karate forms, called the "katas," have to be repeated at least three hundred times to be remembered properly and I worshiped the repetitions. And I love to paint. I paint images of trees again and again...lines of trees. I find it a process of passion; it is like seeing the same movie ten times; it is learning by repeating. When I found the art of running, I knew it was something for me, something that I could be passionate about!

I started running at the age of 46 in Tampa, Florida. One evening in April 1981, I parked my car too far away from a building at the University of South Florida, where I was taking an aerobics class with my friend Cindy Musella, a twenty-eight year old runner. Not wanting to be late, we ran all the way and arrived on time. The distance from my car to the building was only about half a mile but I was exhausted. Somehow, the idea of running to class inspired me. I worked at that time in the University Galleries (known now as the USF Contemporary Art Museum), and after work I started practicing my new-found interest all over the campus, sometimes just in parking lots racing tree to tree. Soon I was able to run a lot more. Getting information from

books and magazines, I became quite educated on the subject. I told my friend Cindy; she was surprised and we started running together. I had found my new passion. The Double Yellow Line was calling me.

I remember the day I decided to run my first marathon... I remember it well, like yesterday. On that fateful day in early 1982, I was taking a coffee break in the USF Art Department front office, discussing the mystique of marathon running. I mentioned an article in the Tampa Tribune about the Boston marathon to my Ph.D. friend and former boss. Casually, oh so casually, I told him that maybe, just maybe, one day I would like to run one. But his response shook me like an earthquake. He started telling me that this event is a race of almost 30 miles and only specially-trained runners could do it. "Okay, okay, I get the drift, maybe I am not going to try running such a top event after all...who am I anyway?" I thought to myself.

"Michelle!" I heard my friend say, "you do not understand... Michelle, dear Michelle, we all love you so much here."

What he really meant is, "Dear Michelle, dear uninformed Michelle, we all love you here, because you are so... subservient...and we need you to stay that way."

"I, myself," my Ph.D. friend continued, "as you know, run a bit and go to the gym regularly and I still won't be able to do such a feat, and you are

older that I am...I am your friend." Great friend, indeed!

For years, men from the USF Art Department Faculty had always been singing a few words from the great Beatles song "Michelle Ma Belle" as I passed them in the hallways. Well, the "Belle" did learn a powerful fact: the "Belle" liked a challenge! Indeed, I was on my way!

Because I did not know any better, I never asked for anybody's help. I trained in complete solitude. It was a little rough on my family. My two daughters were in their late teens, but I knew they would understand later. For my husband it was different, he had a wife with this sudden new hobby... I tried to convert him to my passion, but I failed. "My wife, Michelle the 'Belle,' is a marathon runner now. She does not need my protection: she is liberated!" he said. I had lost the devotion and comfort of a husband ready to protect me against life's unknown blows.

The day was November 21st, 1982, a few days shy of my 48th birthday. The race was the British-American Marathon. At 7 am, we left Tampa Stadium, in the direction of the old Al Lang Stadium in St. Petersburg, via the Gandy Bridge, the Derby Lane Greyhound Racing, 83rd Avenue, 4th Street North...then Coffee Pot Boulevard, The Bayou, and so on. Twenty-six miles and 385 yards of joy and pain, every one imprinted in my mind forever! It was quite hot for a November day and a lot of participants never even crossed the bridge, but I did. I

was triumphant in my deed. It is 1982 and no women are yet allowed to run in a marathon in the Olympics. Not until 1984! I felt like some kind of a pioneer, I felt so good and important when I crossed the finish line in 5 hours and 7 minutes. What a day! What a morning! It is only a little after noon! The sky is blue and clear; I float in the air and smile.

I laugh when I remember the comments of the British sports promoter of the marathon, on the future success of the run: "The wives will want to come for the holidays and watch their husbands run." After the race, my husband complained about how far he had to drive to pick his wife up! But I did not care, running is not a hobby anymore, it is a way of life! And I…am…going…somewhere! My husband was right: I am a marathon runner now! I do not need protection: I am liberated!

And that was just the beginning; I am still running today, twenty-three years later. Today, I am clad in my running outfit, the uniform of The Asphalt Warrior. My armor consists of my running shoes, shorts, T-shirt and ID dog tags. Equipped with my stopwatch and my lightweight portable radio attached to my upper left arm, tuned to the repetitious beat of Hip Hop and Rap, my whole being is entangled with the Double Yellow Line. Do not pass me…I am running! Running gives me courage. I resolve many problems when I run, having all this time to think. I am stuck with myself for better and for worse and I discover, I remember, I learn… and I feel worthy of my passion.

I have to be very careful when I run: I become captivated with myself. This is Utopia...I am not compatible with reality: I am a romantic, smitten with the idea of being the only one out there, the only one who's right! I may run you down if you are not careful...I may be too sure of myself...I may cross the Line. So, I am very prudent, looking around. I only leap to the center of the street, over the Double Yellow Line, when I am certain that nobody's there. And, just as I dreamed as a little girl in Paris, I float in the air and smile!

Then I laugh, because I love a good fight! I am not a fast runner, but I am faster than many. And of course for me, there is always the fresh air on my face, the feeling of flying and the wonder of the yellow chalk on the grey pavement, or could it be the repetitious rhythms of my feet reciting their mantra...Mimi, you can do it...Mimi, you can do it... again and again over the Double Yellow Line?

When I run, I enter the realm of the Double Yellow Line. I am always in the realm of the Double Yellow Line. I *am* the Double Yellow Line and, for sure, I...am...going...somewhere!

Michelle Sauvaget Juristo is a visual artist who was born in Paris, France. Her works are in numerous private and public collections, including the University of South Florida and The City of Tampa's Art and Public Places. She has been a member of the performance art group *Spoken For* and the *Off Center Theatre Artist Collective*. She received a Best of the Bay Critic's Choice Award in 1993. Michelle received her First-degree black belts in Bushido-Ryu Karate in 1989 and in Kasumi-An Nimpo Taijutsu in 1993. She completed four marathons between 1982 and 2003.

September 11ᵗʰ – After the Tears

Kathy Rocha

I didn't know anybody who died on September 11th, but the horror of the sudden attacks left me devastated. In the days that followed, I became obsessed with watching the news. I wanted to know about everything. The recovery efforts at Ground Zero. The hunt for more terrorists. The search for Osama Bin Laden. When were we going to invade Afghanistan? Was it safe to travel now?

I'd start each day by opening the doors of the television cabinet in the corner of my bedroom. Then I'd slip back into bed with the remote control and pull the comforter up to my chin as tightly as I could. It would have been easy to just stay there if I hadn't had a job and a reason to get up and get going.

In the evening, my husband and I would eat dinner on TV tables in front of the large console in the family room and try to catch up on the latest news. Eventually, he'd drift off to the living room with the latest detective novel he was reading, but I'd sit glued to the couch for hours. Tears and tissues were never far away.

Some of the saddest stories were about the people still searching for their missing loved ones. They'd hold up their pictures on camera and plead with reporters to help them find their son or daughter, husband or father, sister or brother or mother alive. For me, their pictures helped to personalize the country's loss. 3,025 innocent lives were lost that day. If this were a natural disaster, like an earthquake in California, it might be easier to bear. But this was a disaster conceived in the minds of men, and carried out in a cold-blooded manner by their hands.

One woman stands out in my memory. She's a mother from Florida, and her daughter, who worked in the World Trade Center, was missing. When she had no word from her daughter, she got in her car and drove straight through the night to get to New York City. I have a daughter about the same age. I hear from her every day. I can't imagine the pain of having "no word" from her, of having to go searching for her, hoping to find her alive. I don't know, but I believe that this woman's story didn't have a happy ending. I think of this mother often and keep her in my prayers.

On September 15th, my husband and I had two weddings to attend. One would have been difficult. Two were downright unbearable. How do you celebrate after 9/11? How do you watch as two lives are joined, blow bubbles and send them off into the future with your blessing? What future? The first wedding was the easiest. A good friend, who was a life-long bachelor, was finally taking the plunge. He'd met "the one," used the "L" word for the first time, and, in spite of 9/11, I was happy for them.

But by the time my husband and I dashed home to get ready for the second wedding, my stomach was tied up in knots and I knew I wouldn't make it through another ceremony. "I can't go to this wedding!" I told him, as we changed our clothes in the master bedroom. Since the groom in the second wedding was someone my husband worked with, I felt I could easily be excused.

"You'll feel better if you go," he assured me.

"No, I won't!" But he didn't budge. He really thought that once the reception started, I would just snap out of it. My mood only got worse. The wedding was being held on a paddlewheel boat that cruised up and down the Intracoastal Waterway. I chose the blandest chicken entree from the menu, and passed on the wine. Other guests at our table were joking and laughing. From where I sat, I could watch couples dancing. How were all of these other people able to put the events of September 11th aside and have such a good time?

We had planned to take a vacation in October, but my heart wasn't in it. Vacations are meant for doing things you enjoy, and I didn't seem to enjoy anything after 9/11. I was even beginning to think that I might need some post 9/11 therapy to help me adjust to the "new normal." My husband insisted that we needed to get away. Well, I wasn't about to travel very far away from Tampa, and I certainly wasn't going to get on an airplane. It wasn't just the thought of flying that terrified me. It was also the fear of becoming stranded miles away from home. Away from my kids, my dog, and everything else that was near and dear to me.

We finally decided to drive up to St. Augustine, on through Savannah, and end up in Charleston, South Carolina. It was a trip I had wanted to take for a long time. I love history, and these cities are rich with it. Maybe a change in scenery would do me some good.

My husband will tell you that this was the first trip we'd ever taken that was determined by the length of time that it would take us to get home. Three hours from St. Augustine. Five hours from Savannah. Seven hours from Charleston. We left on Sunday October 8th, the day the United States invaded Afghanistan. We'd only driven as far as Daytona when we heard the news on the car radio. My first thought was, now there will be some sort of retaliation from the terrorists and maybe we should go home.

But my husband assured me that St. Augustine is only three hours from Tampa and if anything happened, we could get home quickly from there.

The Casa Monica is an elegant, restored hotel in the heart of St. Augustine's historic district. It should have been difficult to get a last minute reservation this time of the year, but the hotel was virtually deserted. No one seemed to be traveling now. Since we were traveling without a definite itinerary, I called my daughter and son-in-law as soon as we checked in. I called them every night while we were on the road. It became a family joke.

Whenever my son-in-law answered the phone, he'd hand it to my daughter. "Here, Hon, it's your mother." I'd tell her exactly where we were and where we thought we'd be going next.

"Mom, you don't have to call us every day."

"Yes, I do," I'd tell her. "What if another attack happens and you don't know where we are? I don't want you to worry." At this point, I think my family was more concerned about me than another terrorist attack.

We'd driven through St. Augustine a few times in the past, but only had a chance to stop for a quick lunch or a hasty tour of the Spanish Fort. Now, having the time to explore, we spent hours visiting museums and historic sites. On a walk down a narrow brick alleyway, I found myself standing in front of the oldest wooden schoolhouse in America, where I overheard a German tourist reading the building's description to his wife. I wanted to run up

and hug them. "Thank you for visiting our country." I wanted to cry. "Thank you for coming to America!" If the situation were reversed, would I be visiting their country?

I tried to imagine what life was like for the early settlers here. Theirs was a harsh existence. Settled by the Spanish, they were attacked by the English and the town was burned. They were plundered by pirates, decimated by Yellow Fever, and battled Indian uprisings. In a brochure, I read that without their courage, perseverance and faith, it is doubtful that St. Augustine would have survived at all.

From St. Augustine, we drove on to Savannah. With its thousands of architecturally significant buildings, Savannah is one of the largest historic areas in the United States. There was a time when cotton was king there and it made the city rich. But a Yellow Fever epidemic re-routed the trading ships, and in many cases they never returned.

As the Civil War was coming to it's bloody con-clusion, General Sherman and 62,000 blue-clad troops marched on the city. Savannah would have been burned to the ground, but Sherman presented the city to President Lincoln as a Christmas gift. Savannah was spared.

At the city's oldest cemetery, I saw a sad reminder of the days when General Sherman and his army camped there. To make room for their tents, they removed the headstones from many of the graves. A long row of these stones is preserved on a brick wall. Many of the inscriptions are poignant

tributes to a lost child, or beloved wife. It seemed so sad to me that they'd never be put back where they belonged.

As we left Savannah, it occurred to me that Osama Bin Laden and his terrorists must never have studied American history. If they had, they wouldn't have underestimated the spirit that makes this country so strong!

I found myself actually looking forward to visiting Charleston. I was already reading the tourist brochures and planning what we'd see next. I decided the first stop would be Magnolia Plantation. We visited the lush gardens and toured the manor house and were transported back to another time. Not a time without its trials. A time when the future of our country was very uncertain. Who knew what tomorrow would bring? This rice plantation was destroyed twice by fire and, after having been rebuilt, was destroyed again by General Sherman as he marched south.

The following morning we took a horse-drawn carriage ride through historic Charleston. Our guide was a young man who was enthusiastic about his city's history. He pointed out that Charleston is a city that has twice been destroyed by fire, once by earthquake, torn apart by the Civil War, brother fighting brother. Yet she stands today. I was finally beginning to feel that when the dust settled at Ground Zero, we would all be standing, too.

It wasn't until we were driving home that I realized something really had changed. We stopped for

the night, and I didn't call the kids. We were planning a trip for Thanksgiving. I was thinking about the future again. The news of the day was not my number one priority. I was more concerned with living my life, each breath, each day that God has given me. Finally, I was dealing with the "new normal"

On the first anniversary of September 11th, I stood flag to flag with 15,000 other people who came down to Bayshore Boulevard in Tampa, not only to remember those who were lost, but to show our support for America and all the brave men and women who defend her freedom today.

I wanted the sun to shine on the first anniversary of September 11th. It didn't. The weatherman had predicted rain, but I put sunglasses in my pocket, and carried an umbrella. "Flags Across the Bayshore" continued in spite of the pouring rain. We all stood our ground, holding our drenched flags high. Why God? I asked. I wanted the sun to shine down on us today. I thought that would make a powerful statement. God, in His infinite wisdom, decided that He would make a statement. He cried.

But after the tears, He always sends a rainbow…

Sometimes we need our comfortable world shaken up a little to get our lives back on track. The tragedy of September 11th was my wake up call. It was time to make some changes in my life. I started by putting the spark back in my marriage, which had grown a little stale after 34 years together.

Then I dusted off an old dream, and started writing again. Eighteen years ago, after yet another short story I had written was rejected, I took all my poems, stories and ideas, and locked them away in the big file drawer in the bottom of my antique oak desk. I never looked at them again. Can you imagine the joy I felt when I opened that drawer after all those years? It was like finding buried treasure. Now I'm writing for me, and the pure pleasure I get just from putting words down on paper.

I have learned that when we embrace life, life embraces us back, and something wonderful happens...

It wasn't that long ago that I wondered why anyone would want to marry or bring children into this post 9/11 world. Well, this morning I sat on the family room couch with my hand on my daughter's growing tummy and I felt my granddaughter move for the very first time. She gave a good strong kick. She's feisty like her mother. I can't wait to meet her!

Kathy Rocha is a wife, mother, and new grand-mother who balances a busy lifestyle of family, career, and creative endeavors. Kathy is the assistant to the CEO of an international hotel/golf company. She seeks quiet spaces and inspirational books in her time off. Kathy served as a Pioneer Girl leader for many years, and is a founding board member of Land O' Sunshine Camp Cherith for Pioneer Girls in Florida.

Change... It's Just Different!

Donna Jenkins

We have all heard the expression "someone is naturally maternal," but is there such a thing as naturally non-maternal?

As I look back to my childhood, I have no memory of playing "house" or playing with baby dolls. As a teenager I was never around young children and my older sister snagged all the babysitting jobs. When dating my future husband, the subject of children was never brought up, which is rather strange in itself. In fact, we never had an in-depth discussion about children until we had been married about four years, which tells you just how in-depth our marriage was. When the subject was finally broached, I was quite unsure about having children. I perceived them to be very unpredictable and a great deal of work. I suppose someone naturally

maternal would have just accepted that fact, but I did what I usually do when I need more information, I went to the library and did some research. I found a great book whose general subject matter was "Having a Baby – Maybe." It stated that there was no good, practical reason to have children. If we all stop to think about it, can any of us think of a good, practical reason to have children? What I was able to derive from reading the book was that the decision to have children comes from the heart, not the head.

After much soul searching, I realized that my heart was trying to tell my head something. Once I got assurance from my husband that he would take a major role in child rearing, we decided to go for it, figuring there must be something to having kids because everyone else seemed to be doing it. A short time later, a beautiful baby girl, Cherie Lynn, was born into my heart. Now, my husband never followed through with taking much of a role in raising our daughter and after twelve years our 'in depth' marriage ended, and I became a single, working mother. No natural instincts here either. Time for more research, so off I went to the library again to get information on child rearing and being a single parent. This was the 80s, a time when the best way to raise children was a hot topic.

After reading a wide variety of different books, I compacted all the information in my head and came up with two main ideas: children need to know they are loved and parents should be involved in

their children's lives. Although most people would say that really was a no-brainer, and maybe I knew that in my heart, I just had to read it to give me solid direction regarding my child-rearing goals. After a lot of deep thought, I decided to follow that advice and my daughter became the center of my life. I took off work to be a chaperone for school field trips, was an assistant brownie leader, attended all of her sporting events from T-ball to soccer, never missing a basketball game or a swim meet. I still blame my expanding posterior on sitting in the bleachers at all of those sporting events. I was on different committees at her school and one after-noon I sat through three back-to-back presentations of a school play in which she had the lead. All of that, in addition to ten years of dance lessons and yearly recitals, made me feel I did pretty well for someone not maternally inclined.

When she was in high school, we started expe-riencing the dreaded "teen years," which as a parent I describe as hiking through a jungle filled with all sorts of wild beasts, dense foliage and unknown dangers with a blind-fold on, never knowing when you will make a wrong turn and fall into a deep dark pit. Even though our relationship survived intact, I could see she was starting to exert her independ-ence. I had spent all of her growing up years trying to teach her how important being independent was and now it was coming back to kick me in the shins. From doing research on the teen years, I knew this

was all part of the weaning away process for both parent and child.

When she picked out a college in South Carolina, nine hours away, I was not sure if I was ready to let her go, but I knew letting go was the right thing to do. I came to the realization that my life would be changing and **I Don't Like Change!** In reviewing my life, I realized that I have been at the same job for over 27 years, lived in the same house close to 26 years and been divorced for 17 years. I had never analyzed how much I feared change up until this time. My new mantra became "Change is not necessarily good or bad, it's just different."

After dropping my daughter off at college that first time, I returned to such a quiet, still house. It is amazing how different a house can feel; it almost echoed with emptiness. In the beginning, I would email her long letters several times a day asking hundreds of questions — what was she doing, how was school, had she eaten that day, was she making new friends — the normal mother questions. I was lucky if I received a short, brief email once a week stating "all was well" or "yeah, o.k." as an answer to one of the hundreds of questions I had asked in my multiples of emails. I think she figured she could cover all the questions I had asked in just that one answer. Even our phone conversations ran the same way. I would ask endless questions and she would give short and brief answers that offered as little information as possible. I felt more distant from

Cherie than the nine-hour travel time. I felt that I was no longer a part of her life. All of my friends were very verbal about how worried they were that I would just fall apart without Cherie being at home and giving me focus. This fact helped me make the decision to not fall into the big black hole of loneliness.

When it finally dawned on me that I was starting to experience the dreaded ENS (Empty Nest Syndrome), I realized I needed to resort to my usual action, or rather reaction, and I did some research. I no longer had to make the trip to the library. I just booted up my computer and did a search under Empty Nest Syndrome to see if I could get any insight or advice. I was very surprised when my search delivered over 9,000 websites about ENS. That was kind of scary. If over 9,000 web sites expounded on the difficulties of having an empty nest, how was I suppose to handle it? In the process of exploring some of the many sites, I found some that described how painful the process was, some described people still trying to deal with an empty nest years after the children had left, and some sites offered information on how others coped and flourished, and even offered suggestions on coping.

One of the suggestions I tried was to make a list of the pros and cons about having an empty nest. The first good thing on my list was I had complete control of the TV remote and could watch anything I wanted at any time. I no longer had to sit through all of those MTV programs that had people embar-

rassing other people or people trying to do damage to themselves just to get a laugh, or other amazingly weird shows that the young people seem to think are entertainment. Another good thing was I didn't have to set a good example at dinnertime by fixing a well-balanced meal each night. I had always had difficulty with figuring out how many of what food group on the food pyramid I was suppose to fix for each meal. Now days, I'm lucky to get *one* of the food groups in my nightly meal. My favorite dinner is ice cream and M&M's. I know ice cream is in the dairy food group but I have yet to find M&M's in any food group and I will gladly admit that it really doesn't matter to me! Switching to the bad things on my list, it came to me that when my house looked like a disaster area, I only had myself to blame. All those years I blamed my daughter for the messy house and I was probably as much to blame for the mess as she and I am still working on coming to grips with that. Another bad thing on my list was that I could no longer use my daughter as an excuse to buy cookies and other forbidden treats at the grocery store. Each time I venture into the grocery store I have to decide whether to let my conscience and waistline dictate if I walk past treats or just buy them and live with the guilt. This sure takes the fun out of grocery shopping!

Another suggestion from my research was to try some new and different activities. One of my first adventures was to do something totally out of my comfort zone — I took a clown class at my

church. Now, I wasn't a natural clown. I tend to be as conservative as a banker in his black pin-stripped suit. I really had to work at building my "clown" personality, so I ventured out to the local Goodwill store. What an adventure! Who knew what a myriad of wonderful choices were out there for a budding clown? I picked out the wildest, brightest and flashiest clothes I could find — some stripes, some polka dots. And nothing matched: a great beginning clown outfit. In the back of my mind, though, I did wonder who buys these clothes to begin with. My clown personality has progressed and now when I put on my prissy clown makeup, my bright, outrageous outfit, my blue wig that brings to mind the little old lady down the street, and my red, glittery button clown nose, it is amazing the transformation from "conservative business woman" to Sparkles the Clown. My favorite clowning event is the children's Christmas party at Metropolitan Ministries, a shelter for homeless families in the area. I have a pin on my outfit that says "Free Hugs" and it is amazing — most of the kids, even the older boys, come over to get a hug from the clown. It is such a wonderful feeling to realize that almost everyone loves a clown. In fact, one year after the kids had left and my clown group was packing up, Santa Claus came over to us and asked if he could have his picture taken with the clowns. This put such a sparkle in all of the clowns' eyes!

Coming home evenings to an empty house and too much time on my hands led me to become

addicted to the home improvement channels on TV, which led me to start redecorating (they always make it look so easy). The first room I tackled was the kitchen because that was the room I seemed to see the most of and I started with a fruit theme. Well, by the end of the job I had fruit canisters, plastic fruit on the top of the refrigerator and the stove, pictures of fruit on the walls, fruit stenciled on the overhang, fruit towels, fruit rugs, fruit dishes and fruit cups. I even had a fruit toaster cover! I have to admit that I might have gone a little overboard. Martha Stewart I'm not.

Something else I tried was golf. I took lessons and I played almost every weekend rain or shine for almost a year. Somewhere along the way I realized that I was not improving so I readjusted my game and started to play what I called the "flog" version of golf (flog is golf spelled backwards). I started making up my own rules like using as many "mulligans" or "do-overs" as I wanted. Of course, every once in a while my partners and I would have to skip a hole after being chastised by the local golf ranger about the speed of our game. I added my own special touches like using the same club the whole game — the sad thing was that no matter what club I used I could only hit a ball 50 yards. Or, I would close my eyes and stand on one foot, picturing in my mind the crane standing on one foot down by the lake, and take a big swing. It always amazed me when most of these shots ended up being better than my norm. It must be a Zen thing. Who knows? I was

having great fun! But I had failed to do my usual research and a little too late I came to realize that golfers are usually very serious about the game of golf so I don't play golf much anymore. Who wants to be that serious about something they are supposed to be enjoying?!

Volunteering has always been important to me and after my daughter went to college, I became involved with the Guardian Ad Litem program in which volunteers represent children in the foster care system in court. It can get discouraging because sometimes you just have to settle for the "least bad" placement since there seems to be no "good" place-ment. Every once in a while something happens to make me feel like I might be making a difference. For example, one of my cases was a twelve year-old girl who should have been going into 8th grade but she was being promoted from 6th grade to 7th only because she had already spent two years in 6th grade. She was reading on a 3rd grade level and spent more time skipping school than attending. I contacted a friend of mine who agreed to tutor her. At the end of 7th grade, this young girl received the annual "Most Improved Student of the Year" award from her school. I wish all of my cases could have such a gratifying conclusion.

Of all the roles I have taken on in the past five years, I still love the role of Mom the best. But I have enjoyed experimenting with life. I still miss my daughter a great deal but I work daily at accept-ing the change in my life and making the most of my

time. My daughter graduated from college and is now attending graduate school at Duke University (you can tell I'm a proud Mom). My emails to her are down to a few brief ones a week and a call when I have a specific subject to discuss. Now she is the one that calls and chastises me for not leaving my cell phone on so she can call and talk to me when she wants to or for not responding to her emails right away. And now, when she leaves after a visit home from college with her 50 pound dog, I tend to appreciate the stillness and quiet in my house — a big change from five years ago.

I'm actually thinking of putting together my very own web site where empty nesters or really anyone with too much time on their hands could go for advice. It would say take some classes, redecorate your house, join a gym, volunteer, do something out of your comfort zone. In other words, "get a life" of your very own. And remember: ***Change is not necessarily good or bad – it's just different!***

Donna Jenkins has always avoided change as much as possible but when her daughter left for college, she realized change was unavoidable and she had to "get a life of her very own." Since then, she has enjoyed experimenting with life and now, along with her full time job as Controller for a real estate development and property management company, she has added several part time jobs, joined a Bunco club, become a clown with a Christian clown group, taken up new hobbies, and volunteers every chance she gets. She has decided change is not necessarily good or bad - it's just "different," and "different" is what keeps life interesting.

Fear of 50

Ellen Winner

The birthday cards started arriving in the mail a full month before my birthday. Not just one or two, but three and four a day, every day. The inordinate profusion of colorful envelopes in the mailbox made our daily mail look like the beginning of holiday catalog season. I can't tell you how loved I felt knowing how much my "best friend" cared that I am older than she is!

Here's a particularly tender tome featuring a grey-haired cartoon lady with an attitude: *"Many people think 50^th birthdays are very serious— Except me. I think **your** 50^th birthday is funny as hell!"*

I turned 50 years old! How did that happen!!! I always figured there would be time: time to change

my career to what I was meant to do, time to fight for the causes I'm always ranting about, time to write the book, or three, whose sheaves of notes crowd my file drawers like forgotten photos waiting for albums. Then last year I turned 49 and the big 5-0 began looming over my head like the stone grey clouds of an imminent storm. It was a milestone that threatened to become a millstone around my neck — my increasingly crêpe-y neck. Crêpe used to be a fabric, now it's a neck texture!

This card's encouraging – a smarmy old lady pulling her face back into a grimacing sneer — *"Pull your ears back and suck in your belly! Show me what you looked like twenty-five years ago!"*

I wanted to lose 50 pounds by the time I reached 50. I've lost 30 pounds many times, and in younger days worked out until I could look in the mirror and smile at what I saw, but now it's just not happening. Now I just want to be okay with how and who I am at 50. Fine! Fine! I know that sounds like a copout, but my friend Cathi, who's a colonel at MacDill Air Force base, also just turned 50 and she looks fabulous. A stunning redhead who makes you confident in the future of our military and our country, she works out religiously to keep her size miniscule figure and she really *does* have abs of steel.

She says it's her job to stay in shape and as part of her regular exercise routine she does 300 sit-ups holding a medicine ball. Can you imagine?! She says even *that* doesn't change skin and gravity. She says, "Yeah, I could wear a bikini, but I'd have to

walk around with my arms straight up the entire time!" She'd appreciate this one –*There are worse things than another birthday......try slipping into a bikini in front of a security video under bad lighting.*

Do you remember setting your hair in orange juice cans or those pink spongy curlers? Wow — you are old! Wow. I did use those pink, spongy curlers. Where have the last 30 years gone and what do I have to show for them? What do I do now? And who in the hell is that middle-aged woman in the mirror? When I graduated college and charged out into the 70s in my hip hugger bell-bottoms and tie-dyed t-shirt with flowers in my long straight hair, I had no idea what to expect or what changes I would face. I didn't expect that in a minute I would be staring in the mirror at an overweight 50-year-old woman who hasn't changed the world.

My mid-life malaise started late last summer when my husband and I drove from Tampa to Daytona Beach to meet with friends from college, some of whom I hadn't seen in nearly 30 years. I haven't been to my college reunions, so I fretted over what to wear that wouldn't make me look too fat and whether I should get my nails done so I would look successful. I arrived at the beach house with my insecurities intact and joined the group standing around the pool. About a dozen former friends who looked either just the same or were completely unrecognizable braced themselves against the stiff offshore breeze. The wind-whipped surf threatened to drown out our small talk as we

awkwardly re-introduced ourselves. Chip and Debbie, sweethearts all through school, were about to marry off the first of their two girls and looked just like they did 30 years ago. Dave and Bonnie looked good, too, considering they had raised five kids of their own, then adopted and/or fostered 32 special needs children. Five years ago, Dave left the finance business to go to seminary and is now pastor in an Orlando church. They had with them a bubbly eight-month-old named Lucy. Chasing after her crawling child, Bonnie said, "Our parenting skills are being wasted on this one. Lucy had seizures at birth and was expected to be severely disabled." In utter incredulity at what they have accomplished, I said, "Looks like you have the gift of an easy one. Enjoy the break." Mike, the tech wonder who had been among the pioneers of PDA technology, was there with his stunning, 19 year-old, Maureen O'Hara (am I dating myself, or what?!) look-alike daughter. She regaled us with harrowing tales of her solo six-month archeological trek across Europe. Her currently unemployed dad cringed.

As I watched my ship of self worth sail into the sunset, I turned to our hostess, Annie, who was visiting from Spain, where she lives with her martial arts instructor husband and their son. Annie lived on my hall in the freshman dorm, and I remember her as a hippy artist with an uncontrollable, curly, blonde mane. She was a cross between Goldie Hawn and Sandy Dennis from the movie *Out of Towners*. (Now I'm definitely dating myself!) We used to

sneak back into the dorm together after midnight runs to the Dunkin Donuts a half hour away in Daytona Beach. That was back when I could actually eat donuts. We didn't have much in common except for our fondness for donuts and Pi Kaps. We both ended up being Rose Queens for our dear Pi Kappa Phi boys.

I asked Annie what she had been doing all this time. She said she wasn't painting anymore. In fact, she told me that one of the two art professors at our small university had loved her work, but the other one didn't. Then one day her roommate mentioned casually, "Have you noticed that everything you do is maternal? You paint pictures of mothers and children, or just children or relationships." Annie retorted, "That can't be right," but she looked through all her work and found that it was right. She thought, "The professor doesn't like my work and this is all I can do." Then she thought about the work of popular artists like Andy Warhol, Peter Max and Jackson Pollock. "I'm just not good enough," she thought. So she stopped. She said, "When I stopped doing what I did, I just dried up." She hasn't painted once in the last 30 years. She made me think of all the things I had wanted to do, but instead ended up doing what I thought other people wanted me to do. Annie and I lived what we thought we *should* be doing, instead of using our gifts. Annie and I were afraid.

Somewhere along the line, we lost our muse and found fear: fear of failure, fear of success, fear

of risk and loss, fear of not being quite good enough. I've spent time and money on therapy and Prozac and I still don't know where the fear comes from. Wherever it comes from, fear changes the way we live. I have spent the last thirty years chasing approval from my parents, my teachers, my bosses, my family and my friends. How could I ever hope to be good enough for them, when I was denying what was good and right for me? *Look at turning 50 this way—in the big antacid of life...you may no longer be an active ingredient.*

Fifty seems to be the point in life where it becomes easier to look backward than forward. As I look back, I realize that my life happened anyway, despite my being the Queen of Denial. (I even have the official bookmark.) Life happens to us whether we are afraid or not and whether we are prepared for it or not. So, here I am turning 50. Okay, what do I have to show for my 50 years? My life sure hasn't been what I expected, but I realize that the things that have happened were not the ones I was afraid of!

When I left college, I had no idea that today I would be faced with 28 emails a day from people who want to lower my mortgage or enlarge my penis. The only spam I wanted to get rid of then was in my diet!

I never expected to get divorced - but I survived it. And now I celebrate 23 years married to my very best friend.

I never expected to battle infertility. But I won — and now I have two great kids to show for it.

I never expected to be the recipient of the emergency adoption of a newborn baby when I was 39. I might survive that. No, really. When I start to creak and groan, I'll think of Bonnie and Dave. They are my age and have an eight-month-old!

I was never afraid of breast cancer - but I beat that, too. And now, I can celebrate my two (much perkier) breasts!

I never expected to fall off that trampoline while checking out the neighbor's landscaping over our fence six years ago. My daughter said she was the only kid in her class who got to call 911 that week. The doctor said I would never run on my broken knee again. So, I *really* celebrated running my first 5K with my daughter last fall.

I've lived through career successes and failures, automobile accidents, major surgeries, and raising children — and I have the scars and gray hair to prove it! And the prescription drugs! Turning 50 has made me change how I look at things. I actually like this card: *Don't worry, you're not having hot flashes. It's your inner child playing with matches!*

My mother always tells me that she liked her 50s best. She said, "There's not as much responsibility for the kids, no worries about getting pregnant, and you're still young enough to be able to do what you want!" Here's a card that lists many good things about getting older*: Neutral colors are in, so your gray hair goes with everything. Stroking chin*

hairs while thinking makes you look smarter. Hot flashes save time — you can undress in less than 30 seconds. You can buy whatever you want without being carded. Forgetfulness keeps your friends interesting 'cause they always have something new to say, and it's worth buying DVDs because you can watch a movie again and again as if you'd never seen it before. Not to mention the many benefits of AARP!

The challenge is to keep looking forward. Luckily, I have a *huge* list of things that I want to do in my life that I haven't done yet — I have goals to keep me moving forward! And, with the stock market and the social security system in the states they are in, I'd say motivation to keep moving forward is not a problem! It's that nasty little voice in your head that says, "you can't" or "what will people think?" that keeps us from doing what we want to do, what is right for us to do. My friend Lydia recently told me... Senior moment. Wait, I have a card for this!!! *Sometimes after you turn 50 you may think of something very important ...Then ZAP! It's gone and your only thought is "what the hell was I thinking about?!"*

What Lydia said was, "You know, Ellen, I always keep my promises to everyone — except to myself." Conquering our fears may not be a matter of trekking through foreign lands alone, hang gliding or eating worms like they do on reality TV. It may entail smaller things that take a lot more commitment, like keeping your promises to yourself.

Each of us at the beach that windy, summer day was doing his or her best with the circumstances of life. No matter what our ages, real success reflected in the faces of those who were living their true lives.

To celebrate turning 50, be adventurous - do something you've always wanted to do but never have... Er...'cuz, , you don't have all that much time left here, ya know.

Well, look at that one. That's it.

My fear of 50 is the fear that my best thirty years are gone and that the outlook for the next thirty years is not quite as exciting. And the next after that? Facing our own mortality is a tough thing to do, but some of us work better on a deadline! The next thirty years is all I have, and I can't count on that, so it is sure time to make the best of every day!

At 50 you've become a national treasure! Unfortunately, Congress has cut the budget for your maintenance. That's okay. I am quite capable of my own maintenance, thank you. I have indeed survived all those years! So what's the point of those fears I've clung to? The older I get, the more I have "been there, done that." And as far as others' expectations, I care, but not that much! I can appreciate what I have accomplished so far, but I'm so looking forward to my next 50 years because there are a lot of things I really *want* to do. I have started already by running a 5K and performing on stage. Now I have a book to write, an invention to market, causes to fight for and trips to take. I have promises to keep. *Turning 50 is like crossing a river, even though you*

can't get around it- you can get over it. Yep, time to start swimming!

After 25 years in Tampa, **Ellen Winner** took her mid-life crisis to heart. With a giant leap, she and her family relocated to western North Carolina to change careers and lifestyles. She has gone from brokering industrial real estate and being active in Commercial Real Estate Women (CREW Tampa Bay) to renovating houses and planting gardens. She is a member of the Carolina Nature Photographers Association and is grateful for the abundance of subject matter in the mountains. Ellen, her husband and two children live in South Asheville and are on a quest to create a resort property where dogs and their people can play and rest.

I Am Julie

Julie Ravelo

Once upon a time, when I was seventeen and a senior in high school, I met a very cute guy named Glenn. We were on a blind date at a University of Miami football game with my cousin, Theresa, and her boyfriend, Carlos. It was quite a feat to pull it off, for you see, I was raised in Miami by strict Catholic parents who had emigrated from Cuba three months before I was born. Every proper first generation Cuban-American young lady brings along a chaperone on all her dates. Many of my friends were plagued by this same problem and abided by it, but I was thoroughly appalled by this cultural rule, so I had long before decided that I simply would not date until I moved away from home. I don't remember exactly what I told my parents on that particular fall day in 1978, but at 7 pm,

Glenn and Carlos picked us up at Theresa's house. We were in our tight, size 6 blue jeans and stylish Lacoste sweaters that we had fretted over all afternoon. Glenn was the perfect gentleman and I fell in love at first sight. It was a magical evening. I didn't even watch the game. I actually hate football if truth be told. After the game, we went to dinner at The Café Brasserie in Coconut Grove. I did not want the night to end.

When Glenn dropped us off at Theresa's, she and I stayed up all night and re-lived the entire evening. But my excitement waned because I had this secret: I was completely horrified at the thought of telling him that my mother would have to join us on any future dates. The following morning, Glenn called several times and I avoided his calls. I didn't know what to do. How would I tell him? Finally, a couple of days later, I reached in my jeans pocket where I had written down his number on an old napkin. I pulled it out and I dialed the number. Ring, ring. "Oigo," answered his grandmother. "May I please speak with Glenn," I asked in Spanish. Oh, my gosh, I was so nervous. "Hello" said a very deep voice on the other end of the receiver. I almost died. We talked for an hour. When I finally explained the chaperoning rule, he was okay with it. He just said, "She sounds like a nice enough lady, we'll just bring her along. Want to go to dinner tomorrow night?"

And so it was. The following evening, Glenn picked up Mom and me in his tan Volkswagen Bug named Fleebo. Mom hopped in the back seat (I didn't feel the least bit guilty about making her cram

into that tiny back seat) and I sat in the front and we drove off to enjoy the first of many chaperoned nights out on the town.

Dating with a chaperone, while not very romantic, can prove to be quite humorous at times. Picture this: a school dance in the cafeteria, chairs line the perimeter of the room. My mom had her own special spot where she liked to sit over by the exit sign where she would often befriend the security guard. Mom always packed what I like to call a "Dance Survival Kit" in her purse. It was so embarrassing. She was always reading a trashy novel. She also had these gloves. They had a flashlight built into the palm of the glove so she could shine the light and use it to read her trashy novel. Can you even imagine?

Glenn and I continued to date with my mother in tow for two years, when my parents finally decided that I was old enough to continue dating him without the pleasure of my mom's company. Which was just great, since it was at 19 that I married him, my high school sweetheart, and became a mom. Soon after Nikki was born, Glenn and I moved away to Mobile, Alabama where he finished school at Spring Hill College and I received my Bachelors degree in nursing from the University of South Alabama.

In Mobile, we did everything together. We went grocery shopping together. We went to the Laundromat together. Nikki and I even went to Glenn's job to just hang out and try to catch him during his dinner break. This sounds so "cute" and

maybe even "romantic," and sometimes it was. Unfortunately, ages 19 and 20 are usually when people start to discover who they are and what they like and don't like. I never had the opportunity or time to do that because I was always "Glenn's wife" or "Nikki's mom" and later "Chris's mom" and "Ryan's mom."

One evening, I was fixing one of my favorite dinners of *mojo* marinated pork tenderloin, Cuban black beans and white rice, and I remember thinking, "What am I doing here?" "What kind of music do I like?" and "What is my favorite color anyway?" The more I thought about it, the more I slammed pots and pans around. I didn't realize that I had become so angry. I found that I didn't really know who Julie was. I realized that I could probably rattle off my spouse's or my children's favorite anything, but not my own. Wow! I had become a submissive, voiceless person who just goes with the flow and has never taken the time to explore who I, myself, might be. I remembered a trip that Glenn and I took to France a while back. While we were gone, our church had put together a family directory of all the parishioners. We had our photograph taken for the directory just before we left. I was very excited about it because we had not taken a family portrait in a very long time. So, when Glenn and I returned from France, one of the first things we did was go to the church to pick up our directory. Once I got my hands on it, I immediately flipped through the pages, looking for our family.

First, I got to the R's, one more page, there it was Ravelo…. "Oh my God, who is that?" I was flabbergasted at how heavy I looked. "What happened to that size 6 body?" I thought. I was so depressed. My eyes filled up with tears. I knew I was heavy, but seeing it in print where I knew everyone else would be seeing it too was too much for me. And, it wasn't just the weight. I was staring at the page in front of me and we all looked so perfect; everyone smiling just so. I was getting increasingly frustrated with having to do EVERYTHING as a family. So, at age 38, I found myself sad and confused and at my top weight of 202 pounds.

Everything came to a head one day shortly after that when everyone wanted to go to a boat show. Everyone except me, that is. I remember saying, more like pleading, "You all go on and I'll stay home," but in response I got the usual, "No, we need to do this as a family."

I sat by the seawall at the boat show pretending to be sick. I was in such a state of despair. Sadness consumed me. I was full of negative thoughts and so negative things kept happening to me. "Oh God, Oh Wisdom, as I sit here overlooking this beautiful blue water," I prayed, "Where are you? Help me out of this mess." I had to do something. Suddenly, I got an urge to write, so I dug a pen and an old napkin out of the bottom of my purse. I was watching my hand write as fast as it could as if it belonged to somebody else. It was as if my soul was writing itself on this napkin and using my hand as its vehicle for expression.

This is the poem that emerged that day:

The Deception

The clouds of my heart lie hidden.
All appears peaceful within.
Clear skies, bright blue hues,
Slight breeze,
The warmth of the golden sun.
Silence, but the sounds of the birds singing
of the glory of this day.
No sign of the turmoil inside.
Within me stirs the grumbling of an
upcoming storm.
Dull skies,
Dreary gray hues,
Gusty winds knock the palm fronds to the ground;
The bitterness of the missing sun.
Painful noise drowns the silence,
No birds sing.
The irony demands introspection.
Many questions arise…
Why the deception?
Who the deceived?
I look to prayer for my answers,
Only to hit a brick wall.
The silence is deafening to endure at length.
Perseverance is the only way out.

WOW! I read it over and over and over! When you pray, you always get an answer. When I finally listened, the Holy Spirit answered me.

That day in 1998, I decided to become an active participant in my life. The first step was a decision towards weight loss, and this time I was determined to keep it off! I started counting fat grams and calories, eating frequent small meals, drinking lots of water and exercising daily. In the beginning, exercise consisted mostly of walking. But, as the weight started coming off, I became more adventurous with exercise. I tried just about everything: step class, yoga, Pilates, running, rollerblading, kickboxing; you name it, I tried it. The key was to move my body daily, to have fun while doing it, and to vary the activity enough so that it did not get boring. Eventually, as I got closer to my goal weight, I took up weight training, which has helped me to boost my metabolism and maintain my weight loss.

At the same time, one of my girlfriends, Jane, was going through a very difficult year with her 8-year-old daughter battling cancer. Five friends organized a weekend getaway for her to a condo on the east coast of Florida. Well, it was May 1st, so we were planning to sun bathe and play on the beach the entire weekend. Wouldn't you know it? It was freezing. So, being the creative women that we were, we opted to stay inside the condo and drink Manhattans, play truth or dare, and dance to Motown music using candlesticks and silverware as

microphones. *"Stop, in the name of love, before you break my heart...think it ooooover."* Or... *"At first I was afraid, I was petrified, kept thinkin' I could never live without you by my side."* We had so much fun! I felt so alive, like I did when I was in high school and having slumber parties with my girl-friends. The one time we did venture out of the condo, we did cartwheels on the beach. Well, actually I did cartwheels on the beach. Try to get a visual of that: 202 pounds, wearing a muu muu, doing a cartwheel; it is a wonder we were not evicted. The Manhattan Sistas were born!

We had such a good time on that weekend that we made a pact to do this on a regular basis. Now, with families and busy lives, it wasn't always feasible to go away, but for the first year, the Sistas made it happen. We had a slumber party at least every other month, usually at Angie's house. One time, we had one of our slumber parties and in our usual Sista way, we were gathered around Angie's counter singing and dancing. Joellen couldn't join us because she and her family were out of town. We all agreed that it wasn't quite the same without Joellen and we wanted her to know it, so we collected some supplies (toilet paper) and all jumped into one car. Since they were out of town, it was easy to get the job done. We TP'ed her front yard so she could return to a beautifully decorated lawn with a Manhattan Sista touch. Now, we usually have a slumber party on our birthdays and once in a while we go out of town.

Along with my weight loss plan, I now had a plan for the rest of me. I made sure I surrounded myself with people who supported me. I could have never made it through all of my changes that first year without the support of my Sistas. Change, according to Webster's Dictionary, means to make different, to alter. When I started becoming an active participant in my life, many things had to change. I could no longer stay passive and let life just happen. I could no longer stay quiet when I really wanted to scream and say, "I don't want it done that way."

Whenever you attempt change, regardless of how good it might be, you can expect a "change back" reaction from those closest to you. When you think about that, it makes sense. If you make a change, then ultimately it will mean a change for them. And although you have come to this realization during your journey of self-discovery, they have probably not been traveling on this journey with you and are not going to be interested in making any changes. The actions and reactions that I got from all my loved ones as I attempted to change my life were plentiful. It is very important to understand the "change back" reaction. Expect it to happen and continue making your changes anyway while staying in open communication with your family or loved ones about what you are doing.

"Who are you and what have you done with my mother?" asked Nikki during one of her visits home from college that first year.

"I guess you going out with your friends means we are on our own for dinner again?" demanded my husband on the third Friday night in a row without his wife.

Despite all of their reactions, I had to plow through and continue with the changes while keeping an eye on my family and coming back to nurture them periodically. That was probably the hardest thing I have ever had to do: keep the balance. Actually, this is the biggest thing I still struggle with now: balance!

Today, the bright yellow sun greets me as it peeks over the Tampa skyline. The bird's morning music serenades me as the gentle breeze skims the surface of my skin and blows the hair off my face. All my senses are awakened as I stretch, say a quick prayer of Thanksgiving, and find the oldies radio station on my Walkman. It all seems surreal, as I perform what has now become my routine rollerblading jaunt along Bayshore Boulevard. This has been a slow journey over the past six years, one that is still unfolding.

I have yet to achieve that magical goal weight, but I have found a method that works for me. I call it my 5 F's: FUN, FITNESS, FAMILY, FRIENDS, and FAITH. They are all important in my method. It is just a matter of balancing them. Imagine my roller blades. Fun, fitness, family and friends are the four wheels and the bar that holds them all together is my faith. So, here I stand still working on me, still struggling with weight. I still love being Glenn's wife,

Nikki's mom, Chris's mom, and Ryan's mom. And now, I love being Julie. I AM JULIE.

And, by the way, my favorite color is PURPLE!

Julie Ravelo was born and raised in Miami where she met and married her high school sweetheart, Glenn. Her journey then took her to Southern Alabama where she completed her Nursing studies while managing marriage and motherhood. While supporting Glenn's career and moving to three big cities, Julie has raised three lovely children, Nikki, Chris and Ryan. Julie also enjoys writing poetry and fiction and designing jewelry.

Seek and Speak Your Story
Workshops

In March 2003, Powerstories Theatre became a non-profit agency with the mission of staging true stories of women and girls to open minds and hearts. A Board of Directors was formed, Fran began working on the Powerstories dream full-time, and the first private grant was received to serve girls in the inner city, which fulfilled one of Fran's long-held dreams.

Another dream also began: Fran started conducting regular, affordable workshops for women from all walks of life to encourage and guide them to seek and speak their stories. Information was distributed asking women, "If you were on stage with a spotlight on you...what life story would you tell?"

Between March 2003 and the writing of this book in March 2004, up to fifteen women gathered each quarter to learn the importance of telling Powerstories and the need for the stories to be resolved before telling them. They discovered their own tales to share and gained a heightened appreciation for listening to others. And then, to conclude the course, they told their stories in front of a large audience and felt the exhilaration and freedom of expressing themselves to others from the heart. These workshops continue, and they have expanded to include advanced workshops to develop stronger stories for even more effective sharing.

Two women, Cara Gubbins and Laurie Santulli, were in the September 2003 workshop. Incredibly moved by the experience, they wanted to do more for Powerstories Theatre. They met on their own and decided that their special gifts of writing and publishing books would help Powerstories reach thousands of people all over the world and reach them more quickly than by theater performances alone. They presented their plans and the Powerstories Book vision began to unfold in glorious colors.

These are their stories.

Finding My Smile

Laurie Santulli

Looking back, I should've known. I remember standing in front of the console TV, you may remember the kind: a long wooden, rectangular mass that sits on the floor, takes up an entire wall and has the TV on one side and the turntable/stereo on the other. I would, without prompting from anyone, pull our piano bench to the center of the room and exercise along with Jack LaLanne, who's now known as the "father of modern fitness." The most incredible thing? I was only a preschooler! By eight years old, I was running track competitively, and by 15 had started lifting weights using Nautilus equipment at a local gym.

I enjoyed exercising and being active. I liked the sense of freedom I felt from "going all out." I

liked the competition, the teamwork and I especially liked winning. I also liked the effects being active in sports had on my body. Believe it or not, my best friend in the 4th grade, Mary, and I would actually compare the size of our thigh muscles to see whose were bigger. Donned in our parochial school plaid skirts, we would swing our legs side-by-side on top of a kid-sized desk, flex our muscles and ask an objective party whose thigh was bigger. I also remember my mother telling me as a very young girl that I would never be fat: I was way too active.

When I was about 16, I walked into our kitchen wearing shorts and a tank top. My mother was standing at the counter in her apron cutting vegetables for our dinner salad. I had just come from the gym, had a little 'pump' from my workout and was vividly imagining myself as a competitive bodybuilder. So I got Mom's attention by producing the best double bicep pose I could muster and exclaiming with a big smile, "Look Mom!" She immediately stopped chopping, looked straight at me and declared, "Ohhhh, Laurie! That's gross!" Instantaneously my smile disappeared, my arms dropped like dead weights to my sides and I slithered out of the kitchen with my deflated muscles and, worse, my deflated dreams.

When it was time for college, I decided to study engineering. I thought it was important to graduate with a marketable degree and I had a strong aptitude for math and science. And since engineers were in demand and had the highest starting salary of any 4-

year degree at the time, I could sense my parents' approval. After graduation, I began working with a large telecom company as a management trainee. I was very serious about my work. After a year of training, I was put in charge of a large project and I felt that if I didn't succeed, my career was hanging in the balance. I basically thought if the project was a success, I'd have a career and if it wasn't, my career was over. I have no idea how many hours per week I was working, but I did volunteer for the overnight shift, which was incredibly taxing physically. I remember being "on call" one weekend and being in such a deep sleep that I didn't even hear the phone ring and another time I overslept for the 11pm shift and another manager who lived nearby the office had to let the crew in. He didn't even bother calling me since he figured I needed the sleep. I was so stressed out that the day before my 24th birthday, I found myself at the hospital undergoing a procedure (and not a very pleasant one) to rule out a bleeding ulcer. It was then that I started to realize my health was just a little bit more important than my work. So I re-committed myself to a regular exercise program and was able to ward off any other stress-related ailments.

My seriousness and workaholism didn't go away however. About eight years into my career, I sat across the booth from my boss, Tom, at a 50s diner discussing my annual review. The omelet and potatoes were above average and so was the review. The review was bound to be since I was always

striving for perfection. And seeking perfection, I asked for some constructive feedback. After a long pause, Tom said to me, "Y'know, Laurie, there is one thing. And Joe Smith pointed this out to me. He said, 'Laurie does a really great job for us, but... does she ever smile?'"

I was a stunned by the comment and really didn't know how to take it. I think I went into some never, never land place at the time-caught off guard by the comment but not prepared to ask what he meant. A few days later, I thought, "What does my smile have to do with anything? They're just after my work, aren't they? They want me to be happy too?"

Several years later, I started with a new company in a new city, married my husband, Rick, and completed the first year of a two-year, full-time executive MBA program. One Spring morning, my husband and I were both getting ready for work in front of our respective sinks and wide mirror in our bathroom. He was wrapped in a towel shaving and I was in my underwear putting on makeup. When I finished putting on my "face," I started out of the room to get dressed and I caught a glimpse of myself in the mirror. I stopped dead in my tracks. I looked at my reflection and then at my body...my reflection...my body. Finally, I pointed at the mirror and screeched, "Whose butt is that?" I certainly didn't want to claim it. Rick and I joked about it that morning, but the very next week I hired a personal trainer.

When my trainer saw me for the first time at his studio, he remarked, "Within a year, you'll be doing a body building show." My ears perked up. "Hmmm," I thought to myself. "A bodybuilding competition... That sounds vaguely familiar." It was as if a light bulb went on. Of course, my trainer had no idea that he had just watered a seed — the seed of a dream long since buried and left for dead.

Within three months of working with my trainer, I had completely transformed my physique with only a one-pound reduction in body weight. By Christmas, I had made the decision to compete in my first bodybuilding show the following March. Now, I knew my mother wouldn't approve and when I floated the idea with my father, he yelled, "You are NOT!" I was 34 years old and do you know what? I felt like I was three years old again. I didn't even feel like working out the whole next week. Even after I had begun my strict training and diet regimen, he challenged me again, "Why don't you become a pilot or something, Laurie?" "Something more honorable," I thought. I couldn't believe it! "Dad, I'm getting my MBA, what more do you want? This is something I'm going to do; I *am* doing. I'd like your support, but either way, I'm doing it!"

And those weren't the only obstacles I had to overcome. I had to have the discipline to get on the Stairmaster for 72 days straight whether I wanted to or not and whether I had the time or not. I made time. I had to pack my pre-cooked, frozen meals in

my suitcase in order to travel for my job. I had to endure my boss holding up a piece of fresh-baked flat bread to my nose at a business dinner. "Oh, Laurie, you must try this. It's soooooo goooood!" I even, believe it or not, workaholic that I was, told my boss that I couldn't travel the few days before the show for 'personal' reasons. I had never, ever done anything like that before.

As I practiced my routine in the days before the show, I had three major fears. The first was that I would fall over while doing my routine. The second was that my skimpy, black competition bikini would fall off. Lastly, I was afraid that I was going to be so petrified while on stage that I wouldn't smile.

On the day of the competition, I did my routine and I didn't fall over. And that skimpy, black bikini…it wasn't going anywhere. It was pasted on with wood glue, the aerosol adhesive you get at Home Depot. Some of my most delicate skin actually went with the bikini when I took it off after the show. And my smile? My smile was so wide it went from ear to ear and I held it for so long that my cheeks actually hurt. The joy and sense of accomplishment I experienced were overwhelming. I had done it! My dream from half a lifetime ago had finally come true!

That night, as I stood backstage, awaiting the final contest results, I knew I had done everything I could do to be my best that day. No matter what happened, I kept telling myself, I had nothing to lose. And as I was convincing myself of this…they announced my name! Laurie Santulli! I was the win-

ner in the Over-30 Women's Division of the body-building competition!

As I walked out on the stage, it was as if everything was in slow motion. The roar of the audience resonated within me. I distinctly heard my father's proud, deep voice from the audience, "Alright, Laurie!" I grasped the trophy, raised it in the air and with both arms fully outstretched, felt so free and so powerful, it was as if I had wings! I thanked the audience for their cheers and support and triumphed, "so this is what life can feel like!" In the very next instant, out of nowhere, I clearly heard another fatherly voice, "Your life will never be the same."

It was true! As I left the stage that night, with my trophy in hand, it was a new Laurie that emerged. A Laurie that had rediscovered her smile and would never, could never, ever let it go again.

Laurie Santulli competed in and won a second body building competition that year. The following year, she resigned from corporate life and created Sound Decisions Consulting, which helps executives make more effective business and technology decisions. She is co-author of *Maintain Balance in an Unsteady World* and offers programs that help individuals live more full and intentional lives. Laurie lives in Tampa, Florida with her husband, Rick Plummer, and their two dogs. She smiles regularly.

On Becoming a Scientist

Cara Gubbins

As far back as I can remember, I've always loved the ocean. In fact, when I was three years old, my nickname was Seal Baby, because I would spend so much time swimming underwater whenever my family went to the pool or the beach. When I was six, Sunday nights were reserved exclusively for watching Jacques Cousteau on television. Even then, I knew that I wanted to be a marine biologist. So when I was a junior in high school and had the opportunity to be a volunteer on a research project studying communication between people and wild dolphins, I jumped at the chance.

I flew from San Francisco to Miami and the research boat sailed from there to the Bahamas. We anchored at a place called the Little Sand Banks,

which is miles from any piece of land. When you get out there, all you can see in any direction is blue ocean and blue sky. The sandy bottom is perfectly white and the water is perfectly clear and only twenty to thirty feet deep, depending on the tides.

Every day, we'd wait for dolphins to swim by. When they did, the scientists jumped in the water and did their research and the volunteers jumped in the water, too. Our job was to identify individuals by their spotting patterns and nicks and scars on their bodies. But mostly we just swam with the dolphins. At least that's what I thought. Actually, I was one of the few people getting close to the dolphins. By the middle of the week, the other volunteers were handing me their cameras as I jumped in the water because they weren't getting close enough to get good pictures of the dolphins.

On the day before we were to sail home, a huge group of at least thirty dolphins surrounded the boat. Everyone raced into the water. Dolphins of all ages and sizes surrounded us. Mothers whizzed past me with their calves in tow; juveniles swam in large packs, circling the swimmers while remaining a few tantalizing inches away from outstretched hands; older dolphins cruised the perimeter, eyeing the humans and watching for danger. I watched, fascinated, as every aspect of dolphin life unfolded before my eyes.

I broke out of my reverie and started swimming slowly through the group, my head swiveling from side to side, taking it all in. Then three dolphins sin-

gled me out from the other swimmers. One swam on my left, one on my right and the third was underneath me. We swam as a unit, up to the surface to breathe, down to the sandy bottom, circling in and around each other. I have no idea how long I swam like that with them. Time just stood still and nothing else existed. At one point, I realized I had no idea where I was so I surfaced and looked around for the boat. I was only fifty feet or so away from it, not far at all, really, so I kept swimming with the three dolphins. They had found a piece of kelp and were playing tag with it, dragging it through the water on a pectoral fin before passing it off to the next dolphin. A little while later, I noticed that I didn't see any other people or dolphins around us.

Again, I surfaced and looked for the boat. This time I was a couple hundred yards from the boat and I could see that everyone else was out of the water and the big group of dolphins was heading away from the boat and away from me and my three dolphins. Under the water, the three dolphins were frozen, waiting for me. I sank back underwater and re-joined them. We swam together, but now they were trying to catch up to their group and I lagged behind. They stopped and looked back at me, waiting. I caught up to them once more and they started quickly toward their group. Again I fell behind, watching them swim into the distance. They stopped and looked back at me one last time. Every cell in my body wanted to follow them. Well...at least one cell in my body knew that meant certain death! I

knew that I had to return to the boat and started swimming back. As I glimpsed over my shoulder, the trio disappeared into the dark, blue ocean.

Back on the boat, I knew that I had found my calling. I would go home, go to college, get a Ph.D. and come back here and study these dolphins for the rest of my life. I had found my home and my life's dream. I had found my true self.

I went home, graduated from high school and started college. I was on my divine path, fulfilling my dream. The summer after my freshman year, I was traveling with my mom and sister, visiting my aunt and uncle in Greece. One day, I ran into a guy I had dated the previous summer. We went out to dinner and then for a walk on the beach. It was a beautiful night. The air was warm and a soft breeze carried the briny scent of the ocean inland. We took off our shoes and the sand was cool on our feet. We walked and talked and had the entire beach to ourselves. When we noticed a log that had washed ashore, we sat down and looked up at the stars. And then he made a pass at me. But, as nice as the evening was, I was over this guy; there was nothing there for me. So I said, "No, thanks." But he insisted. We went back and forth. Before I knew it, I was talking him out of forcing me to have sex with him. And then he raped me. Right there on that cold sand.

Afterward, he walked me home to my uncle's house, kissed me on the cheek and walked away. I watched him walk down the cobblestone street and then just stood there, staring at that blue door to my

uncle's house. I don't know how long I stood there, unmoving. Time stood still for me. Finally, I opened the door, went inside and went straight to bed. And I didn't tell a soul what had happened.

That fall, I returned to college. On the outside, I'm sure I seemed the same. I did well in my classes, joined the crew team and competed in races all over the state, having a great time with my teammates. I kept my secret inside of me, sharing it with no one. I had blocked that event out of my mind, ignoring the turmoil inside me, locking the experience away in a vault. But it was a leaky vault, and this acid was eating away at me, destroying my self-confidence.

Two years later, my mom took a self-help weekend workshop and recommended it to me. I signed up, not thinking much about it. But one of the exercises involved examining unexamined events in our lives. I finally said the words out loud and told another human being about being raped. After I told my workshop partner, I went home and told my mom what had happened on our vacation trip together. And then I told my father and my sister and my uncle and aunt. Talking about it was the first step toward healing my psychological wounds. But when I graduated from college a year later, I didn't even consider applying to graduate school. Even though I had a 3.5 GPA, I didn't think I was smart enough to get a PhD. I had lost my dream of being a marine biologist. I had lost myself.

But, my life took another unpredictable turn. A two-day whitewater rafting trip with friends led into a summer job as a rafting guide. That summer job led into more opportunities and, within a year, I had a fulltime job leading river trips all over the world. I kayaked through the Grand Canyon, led paddle crews down rivers in Costa Rica, and explored the Bashkaus River in Siberia on a team of American and Russian experts. And something unexpected happened: through facing very real physical danger on a regular basis and becoming a leader responsible for not only my safety but also the safety of other people, I regained my self-confidence and found myself again.

After three years of guiding full-time, I resurrected my dream and tested the academic waters, applying to graduate school, determined to pursue my dream again. I got accepted in the master's program in biology at San Francisco State University. Over the next three years, I learned about anatomy and physiology, ecology and conservation. I studied molecular genetics and marine biology. I conducted my own research project on the spatial relationships and social behavior of mother dolphins and their infants for my thesis and spent every New Year's Day volunteering at a dolphin research lab — determined to start every year on positive note, consciously and actively pursuing my dream. Through my class work and research, I discovered I had a knack for designing experiments. I was even good at statistics! I received straight A's at San Francisco

State and published a paper based on my master's thesis in an international scientific journal.

Most importantly, my experience at San Francisco State gave me the confidence to apply to several good PhD programs at schools all over the country. Accepted to my first choice school, I received scholarships for my classwork and research grants for my dissertation study. I spent five years studying wild bottlenose dolphins in South Carolina, learning about community structure, feeding strategies, ranging patterns and the complex relationships between animals, plants, water and land. I watched newborn babies, just a few hours old, jumping out of the water to breathe next to their moms. I learned to recognize by sight the few dolphins in one community that had perfected the dangerous practice of chasing fish onto land for easier capture, beaching themselves completely in the process. These dolphins learned how to wiggle and slide back into the water after picking up the fish, avoiding the hot sun and the crushing effect of gravity on their ocean-adapted bodies. (For uninitiated dolphins in other social groups, this dangerous feeding technique meant certain death, not an easy lunch.) I spent over three hours on a lazy, hot afternoon watching a group of four dolphins swim in a resting pattern, making a synchronized figure eight as they slept with one half of their brains at a time. When my research was complete, I took all the data to my office and put my statistical and explanatory skills to work, emerging two years later with my dis-

sertation, which I successfully defended in front of my professors and classmates.

My whole family attended my graduation. It was held outdoors, on the main quad at the University of Nevada Reno. The sycamore trees bloomed pink and white, circling the stage and the rows of chairs for the graduates. The warm air was soft and fragrant, perfectly suiting my mood. When my name was called, I walked confidently up onto the stage with my advisor following right behind me. I shook the president's hand and accepted my diploma. Then I knelt down as my advisor placed my doctoral hood over my head. In that instant, I had my PhD. As I exited the stage, I was walking right toward my family, sitting on the grass. Even though the president had asked everyone to hold their applause, my family was on their feet, cheering and whistling and clapping for me. A huge smile spread across my face and, entirely of their own volition, my arms lifted up high over my head in victory. I had done it. I had fulfilled my dream.

As I watched the other students graduate, I had time to consider my unconventional academic journey and how the unpredictable encounters with people and animals had shaped my life and determined my path. I thought about those three dolphins that froze in their tracks, waiting for my decision. What were they doing now? Were they waiting for me in the warm waters of the Bahamas? In my reverie, I smiled, nodded my head, and silently promised them, "You're next. I'll see you soon."

Cara Gubbins, Ph.D., began conducting scientific research as a high school student in 1981 and she received her doctorate in Ecology, Evolution and Conservation Biology in 2000. She has studied harbor seals, elephant seals, spotted dolphins, white-sided dolphins, bottlenose dolphins, pilot whales, manatees, sea turtles and desert fish and lizards. Cara and her research have been featured on CNN, the BBC, the Discovery Channel, and National Geographic Specials. She is the author of two award-winning books about dolphins, *The Dolphins of Hilton Head* and *Florida Dolphins*, an award-winning inspirational children's book, *Before You Were Born*, and numerous magazine articles, newspaper columns, stories and essays. Cara currently lives in Chico, California with her husband, Chris, daughter, Alexis, and their Australian shepherd, Iko.

Epilogue

The Powerstories dream started out in the heart of one but it is now a dream of many hearts. Our vision is for all people everywhere to love and honor themselves and others. Our mission for accomplishing this is to stage inspiring, true stories worldwide to invest lives with more meaning, open minds and hearts, and connect us more vitally with others.

We encourage you to contact us to help with our mission. We are looking for workshop facilitators to learn the Powerstory concept and teach the "Seek and Speak Your Story" workshop to women in their communities. We envision a Powerstories Theatre presence in all large and small cities worldwide. We are also looking for theatre performance and seminar opportunities in your areas.

Our mission is being accomplished through the following:

Theatre productions by women - Two shows are currently available for national and international audiences. Both "Let the Stories Move You" and "Clarity Cometh" feature women telling their *own inspirational stories* and are excellent for the general public, corporations, women's organizations, colleges, and communities. Custom shows can also be produced.

"Seek and Speak Your Story" workshop for women - This workshop begins by asking women, "if you were on stage with a spotlight on you...what life story would you tell?" This ten-hour workshop helps women discover stories of their lives that they want to share with others and to present them to an audience.

Powerstories Circles - This informal gathering of women is a natural outcome of the "Seek and Speak" workshops. Women meet regularly in their home or community place to tell Powerstories.

Powerstories Seminars for Women - The ensemble of all the above programs offered in a 2-day seminar. A full theatrical production will be performed followed by workshops on "Seek and Speak Your Story." Participants are left with workshop materials

and a facilitator guide on how to begin Powerstories Circles in their own city.

Theatre productions and workshops for Girls - The Girl*stories* workshop project helps young girls increase their sense of becoming who they dream they can be through seeking and telling true stories. Currently offerered through four social service agencies in Tampa, Florida. Girl*stories* theatre to be implemented soon.

For more information, contact Powerstories Theatre, PO Box 18021, Tampa, FL 33679 or call 813-258-1898 or visit us on-line at www.powerstories.com.

Recommended Reading

The contributing authors have selected their favorite and most important books to recommend to the reader. Enjoy!

A Course in Miracles: Text, Workbook, & Manual for Teachers

Andrews, Andy, The Traveler's Gift

Assaraf, John, The Street Kid's Guide to Having It All

Bach, Richard, Illusions

Bach, Richard, Jonathon Livingston Seagull

Bach, Richard, One

Bah'u'llah, Spiritual Reality

Braden, Gregg, Walking Between the Worlds, The Science of Compassion

Bradshaw, John, Homecoming: Reclaiming and Championing Your Inner Child

Brandt/Coita, Psalms/Now

Breathnach, Sarah, Simple Abundance

Brennan, Barbara Ann, Light Emerging, The Journey of Personal Healing

Brown, Margaret Wise, Runaway Bunny

Brown, Tom, Jr., The Tracker

Buck, Pearl S., House-of-Earth

Burns, Olive Ann, Cold Sassy Tree

Buscaglia, Leo, Ph.D., Living, Loving & Learning

Cameron, Julia, The Artist's Way

Cameron, Julia, The Right to Write

Chopra, Deepak, The Seven Spiritual Laws of Success

Cousins, Norman, Head First

Dackman, Linda, Affirmations, Meditations, and Encouragements for Women Living with Breast Cancer

De Saint-Exupery, Antoine, The Little Prince

DesMaisons, Katherine, Ph.D., Potatoes Not Prozac – How to Control Depression, Food Cravings and Weight Gain

Dostoyevsky, Fyodor, Crime and Punishment

Estes, Clarissa Pinkola, Women Who Run With the Wolves: Myths and Stories of the Wild Woman Archetype

Franklin, Jon, Writing for Story

Germer, Fawn, Hard Won Wisdom

Goleman, Daniel, Emotional Intelligence: Why It Can Matter More Than IQ

Grabhorn, Lynn, Excuse Me, Your Life Is Waiting: The Astonishing Power of Feelings

Gubbins, Cara, The Dolphins of Hilton Head, Their Natural History

Hanh, Thich Nhat, Peace Is Every Step, The Path of Mindfulness in Everyday Life

Hanh, Thich Nhat, The Miracle of Mindfulness

Helmstetter, Shad, What to Say When You Talk to Your Self

Hyams, Joe, Zen in the Martial Arts

Jeffers, Susan, Feel the Fear and Do It Anyway

Jenkins, Elizabeth, Elizabeth the Great

Jung, Carl G. (editor), Man and His Symbols

Klemp, Harold, Our Spiritual Wake-Up Calls

Kushner, Dr. Harold S., When Bad Things Happen To Good People

Lewis, C.S., The Lion, the Witch and the Wardrobe

Mafi, Maryam and Azima Melita Kolin (translators), Rumi-Hidden Music, Paintings and Poems

Maguire, Jack, The Power of Personal Storytelling

Maltz, Maxwell, Psycho-Cybernetics

Markham, Beryl, West With the Wind

McWhorter, Patricia, Ph.D., Cry of Our Native Soul

Mitchell, Margaret, Gone With the Wind

Morgan, Marlo, Mutant Message Down Under

Myss, Caroline, Sacred Contract

Myss, Caroline, Spiritual Madness

Myss, Carolyn, Anatomy of the Spirit

Northrup, Christiane, M.D., Women's Body Women's Wisdom

Norwood, Robin, Women Who Love Too Much: When You Keep Wishing and Hoping He'll Change

Palmer, Parker, Let Your Life Speak

Redfield, James, The Celestine Prophecy

Redmond, Lynn, When the Drummers Were Women, A Spiritual History of Rhythm

Robbins, Anthony, Awaken The Giant Within: How To Take Immediate Control Of Your Mental, Emotional, Physical And Financial Destiny!

Ruiz, Miguel, The Four Agreements

SARK, Succulent Wild Woman

SARK, The Bodacious Book of Succulence

SARK, The Creative Companion

Shields, Carol, The Stone Diaries

Stanton, Judith and Pat Rodegast, Emmanuel's Book (Books I through III)

Stanton, Judith and Pat Rodegast, Emmanuel's
 Book II: The Choice for Love
Steptoe, John, The Story of Jumping Mouse
The Holy Bible, New American Standard Version
Tolle, Eckhart, The Power of Now
Twain, Mark, Tom Sawyer
Walsch, Neale Donald, Converations With God
 (Books 1 through 4)
Wilde, Oscar, The Picture of Dorian Gray
Williams, Marta, Learning Their Language
Williams, Mason, The Mason Williams Reading
 Matter
Williamson, Marianne, A Return to Love
Windle, Janice Woods, True Women

What people are saying about Powerstories:

I laughed until my sides hurt when Deanna talked about drying her wig by hanging it on the ceiling fan while undergoing chemotherapy. Chills ran down my spine when Angela talked about being so poor that she captured poisonous snakes in the everglades to sell them for their venom. And then Joy's exuberance for life recharged my soul and reminded me that we have to take the bad with the good. Such is life. It reminded me that I am lucky to be alive.

Diane Jamai, President "The Right Fit 4 U"

This is a must see event.

Billie Glimpse

This show transforms and heals its audience.

Robin Hankins

As a tribute to women and what they have to say - this will be touching and profound.

Debbie Baker

Julie's story really hit home. Believe me, the "chaperonas" were in full force when I was a teenager in Cuban-American Miami of the 70's. Any working mother today can relate to her struggle in looking for herself: it's easy to get lost, when you are giving constantly to family, friends and responsibility. Julie came full circle, she is truly an inspiration.

Alina Mayo Azze, News Anchor, WLTV Channel 23, Miami, FL

The lessons of life are often packaged and delivered with such pain and sorrow. How do we survive? Sharing through our stories can be a cathartic journey from darkness into a past of healing. Renee Dignard-Fung takes tremendous risks in telling her story - changing her life crisis of abuse and neglect into an opportunity to love. Her courage to share her story serves as an example on how to not only survive but to triumph.

Susan Carmichael, author of
Costa Rica: In The Belly of Paradise.

I just quit my job to follow my dream of starting a non-profit to provide services to people with disabilities. This show was just what I needed.

Becki Forsell

The Asphalt Warrior: ... I am not compatible with reality.. A remarkable line from a story driven by the footprint of a runner's pace. In actuality, the author is all too real. From Paris to Florida, from childhood to maturity, Juristo travels for the sake of the moment, the inclination of the journey. She floats, she runs, she appropriates the Double Yellow Line all with the weight and assurance of a sojourner. This text is not meant to be finished, but weaved to an epilogue before the ending. This is a story of a warrior, who defines a world not by means of battles but by triumphs. An account of personal conquests and a road build a rung at a time.

Maria Emilia Castagliola, artist

I just saw one of the Powerstory Plays and it was wonderful! All women should have a chance to see this and participate!

Ada Sanchez

Powerstories need to be national!

Cate White

This is a moving, heartwarming experience, which will teach you about the power of the inner self. You must see this show.

Warmly, Allison Young

Wonderful, inspiring stories - to be shared!!

Lucy Shaw

I went to this Powerstories and really enjoyed it. Love it.

Pat Gallagher

Your Powerstories Theatre production "Let the Stories Move You" was the most inspiring and impactful theatre production I have ever seen. As a psychiatrist and founder of Women's Way, a seminar company honoring women, I feel that every woman should experience this production and get inspired to honor their own story. My friends, colleagues and patients (teenage - middle age) were deeply moved and ignited by the women's stories and their courage. Thank you, Fran, for honoring your dream and touching us all so completely.

In Joy, Susan List Mike, MD

Congratulations to you and the wonderful women of Powerstories Theatre for a HUGE SUCCESS! The work was important, uplifting, extremely well-presented and I left the theatre filled with energy and zeal ready to tackle those things that must be done by me!

With verve, Donna Cutting

This is a GREAT show.

Paul Whiting

These powerful ladies are POWERFUL!

Ann Wagner

The stories told in this entertaining, motivational performance of Powerstories are universal to all women from all walks of life and all parts of the world. Another woman, Eleanor Roosevelt, once said, "the purpose of life is to live it, to taste experience to the utmost, to reach out eagerly and without fear for newer and richer experiences." The performers in Powerstories shared their experiences and gave a richer, fuller meaning to my life.

Judy Wade, Tampa Business and Professional Women
– The Entrepreneur's Source

You don't know what you are missing! I'm a workshop participant. Powerstories is great!

Karen Conley

It's amazing the stories these women have to tell.

Ofelia Via

I have been lucky enough to attend three perform-
ances and would go again in a heartbeat. The per-
formance will make every woman look within her-
self and her mind will form her own presentation of
her own story.

Michele Phillips, Charter President,
Carrollwood Business and Professional Women

I feel sure that this program could be of benefit to all
women of all ages who are wanting to find an
answer, hear of another's triumph, or just need an
attitude adjustment and personal lift. Or, maybe,
they have a "story" of their own that we all need to
hear. What a wonderful gift to receive.

Judy Gay

I saw the small production of Powerstories the other
night at a local Business and Professional Women
dinner in Carrollwood. It was just wonderful and I
am glad that I drove through the deluge that night
instead of going home. It inspired me to resolve my
own story at long last. I felt an immediate connec-
tion with the power of story telling and was able to
identify with different parts of the three women's sto-
ries. Although intellectually we know that we all
have stories to tell that are unique and individual to
us, it is exciting to see and hear women put them-
selves on the line and stand up to tell the story.
Powerstories' true power is the opportunity for
women to connect, identify, and believe in each
other.

Irene Levine,
Carrollwood Business and Professional Women

Congratulations on a wonderful production of "Let The Stories Move You." I attended the Friday performance and enjoyed it very much. What outstanding, inspiring stories and performances. I'll remember the experience for a long time.

Dorothy Blackwell

It seemed to me that the women on stage were celebrating their losses in life, be they through death, disease, prejudice or other life circumstance. There is always pain in adversity, and there is always growth in pain, if only we stop writhing long enough to experience it. These women stopped and walked through their pain to come out on the other side, triumphant, tall and regal. In these losses was housed their growth potential. They were so much richer not in spite of the losses, but because of them. Each open wound allowed the light to shine through in its full splendor. I thank you, Fran Powers, for creating a safe Haven for these women to gather together to partake in the ancient art of story telling replete with its magical powers of healing, and for others to come listen to each individual, divinely inspirational message. I hope you continue to touch many more souls out there. It is a process breathtakingly powerful and beautiful.

A listener, Sushama Kirtikar

Michelle Juristo's story is one told with honesty, expressed through dedication, and celebrated in her independence. Run, Michelle, run!
Alexa Favata, Associate Director Institute for Research in Art, University of South Florida Contemporary Art Museum

The Powerstories presentation was wonderful and "moving." What a great accomplishment and realization of a dream and passion for you! I worked with Angela at the Center for Women and always admired her so much – for all she has done and all of who she is. Thanks for sharing your dream and I'm thrilled to have attended.

Shirley Callaway

I feel so fortunate to have been able to attend the Thursday evening performance along with family and friends. It was a very moving event, and we will all benefit from your powerful stories on the challenges, which you have met. The words which you have chosen to tell of your experiences will be an inspiration to those in your audience. It was truly awesome.

Kitty Bryan

Congratulations! I was privileged to be in the audience this past week when "Powerstories" emerged! What an excellent opportunity for us as women to celebrate one another!! The connectedness of the stories and the connectedness they brought the audience with the tellers were significant. You, as direc-

tor, need to take a major bow! You have offered our community something relevant and critical. Before I went the other night and during the performance, I kept thinking about various venues where these women could impact and make important differences. Hope to talk more with you about that. Have a good week! I can't imagine what it will be like, going to work AFTER this "high."

Sally Speer

Congratulations! Your dreams have become your reality. Thank you for your inspiring Powerstories last Friday evening.

Amy Elizabeth Bishop

Excellent and Awesome and Powerfully Moving. INDEED!!! Thank you! Please be sure and advise me if there are plans to share your stories in Pinellas County and/or beyond or again in Tampa.

Looking forward to it, Lailja (aka Bonnie)

I really enjoyed seeing your performance, it left a lasting impression on me. I have been bragging about you to everyone here in St. Louis.

Loretta Beckman

Fran! I'm just back from "Let the Stories Move You" and I loved it. All of you did a WONderful job! Such inspirations! Thanks for alerting me to it! Seemed like a nice turnout tonight. I hope you were pleased. I look forward to seeing you again, hopefully soon!

Betsy Brown

Good morning Fran: I just had to tell you how much we all enjoyed the performance last night. We left the theatre with uplifted spirits and inspiration! Our girls found it fascinating, as well as how they could relate to the stories. It was a wonderful experience for them. I'm bursting at the seams to pass on to others and let them know what a moving, spiritual and motivational event we experienced last evening. Thank you so much and to all the Powerstories performers!

Sincerely, Rosemary Menna

Powerstories are a tribute to ALL women! Fran's ability to teach women to find their passion and life-changing moments will be her legacy. The shows feel like an extraordinary bonding, which captures your spirit and makes you want to tell your own story!

Christine Tarbox

About the Authors

Cara Gubbins, Ph.D. - Cara Gubbins is the primary editor for the Powerstories book. She developed and conducted the first Powerstories Writing Workshop for all contributing Powerstories authors, taking the lead role in educating the performers on the differences between telling a story for the reading versus the listening audience, and worked individually with each author to help develop the stories for this book. She was also the project liaison between the writing team and JADA Press.

Cara began conducting scientific research as a high school student in 1981. She holds a doctorate in Ecology, Evolution and Conservation Biology. She is the author of three award-winning books, a newspaper column, and numerous magazine articles, stories and essays.

Laurie Santulli, M.B.A. - Laurie Santulli is the Project Manager for the Powerstories book. She researched publishing options, organized data to be analyzed and presented, assisted with the Powerstory Writing Workshop, distributed detailed communications of tasks to be completed, and assisted with editing. She kept twenty contributing authors and the writing team organized and on task.

Laurie is the president of Sound Decisions, a consulting firm dedicated to advancing organizational effectiveness and improving individual productivity. She is a professional coach and facilitator and co-author of the book "Maintain Balance in an Unsteady World."

Fran Taylor Powers, M.Ed. - Fran Powers is the Founder of Powerstories Theatre of Tampa Bay, Inc. She selected stories for each show, provided coaching on telling the stories for performance, wrote, directed and produced two original plays connecting the stories, and conducted workshops on how to seek and speak your story. Fran also listened with enthusiasm when two workshop attendees, Cara Gubbins and Laurie Santulli, presented their creative idea on how to further the Powerstories mission through collaborating on the Powerstories book.

Fran is also the president of Fran Taylor Powers, Inc. providing training to individuals and corporations on public speaking.

Printed in the United States
20684LVS00001B/220-276

9 781932 993004